珠寶設計原創繪本

A Sketchbook
of Jewellery Designs

臺灣珠寶藝術學院 主編

項飾與套組

Necklaces and Sets

寶島臺灣幾乎沒有蘊藏任何寶石與貴金屬，現階段除少數寶石級紅珊瑚，珠寶原料基本上全數仰賴外地進口。是以，在臺灣經營從事珠寶事業，自然要以「設計＋製造」為利基；倘若臺灣失去了「珠寶設計」和「珠寶工藝」這兩項能力，無法在地生產製造，一昧地仰賴「進口」，意味著臺灣珠寶業將永遠輸在起跑點上。

《珠寶設計原創繪本》是臺灣珠寶技職教育史上，第一本學員珠寶設計的創作專輯，匯聚了2011–2020年期間，主要的國際珠寶設計比賽參賽作品。編輯歸納：「一、項飾及套組。二、戒飾。三、胸飾。四、耳飾。五、腕飾。六、其他首飾形式。」共六大類。其中的項飾及套組，另外分成：「1.彩寶。2.鑽石。3.翡翠。4.珍珠。5.歐泊。6.珊瑚。7.黃金。8.精選成品。」以便讀者索引賞析。

根據《全球設計觀察》報告，臺灣設計競爭力名列前10大。在國際四大重點設計競賽如「德國iF、德國red dot、美國IDEA、日本Good Design Award」，臺灣各項設計表現均榮獲國際相當高度讚賞，成績豐碩傲人。相同的，臺灣在國際珠寶設計競賽中的表現，亦是可圈可點，表現亮眼。

《珠寶設計原創繪本》中的學員們來自各行各業，絕大多數人並非美術科班背景，甚至毫無繪畫基礎，僅憑著對珠寶藝術的熱愛進而投入學習，通過三個月的密集課程訓練養成，應用【珠寶設計系統】發想創作，再經過無數次的修改，一筆一畫慢慢勾勒，形塑出別具風格的珠寶藝術。無論是形式或內容的詮釋，或材料或題材的表現，均有脈絡可依循，有創意靈感可以對照，絕非天馬行空。

臺灣珠寶藝術學院之學員已勇奪的國際珠寶設計比賽獎項數以百計，其中，更有超過50多件珠寶設計作品，贏得「世界第一」的肯定，並且獲得國內外知名珠寶企業的贊助，製造成珠寶實品，讓設計成真，意義非凡。

There are hardly any precious stones or precious metals in Taiwan. At present, except for a small amount of gem-quality red coral, Taiwan is dependent on imports for all the raw materials used in jewellery. That is why those engaged in the jewellery business in Taiwan would naturally want to use 'design + manufacturing' as their niche. Should Taiwan lose its capability in the two fields of 'jewellery design' and 'jewellery craftsmanship,' there would be no way to produce and manufacture locally, and we would have to rely on 'imports.' What this implies is that Taiwanese jewellers would always lose at the starting point.

The birth of the Sketchbook of Jewellery Designs is the first creative works album of student jewellery design in the history of jewellery vocational education in Taiwan. Major student entries in the Jewellery Arts Institute of Taiwan's International Jewellery Design Competition from 2011 to 2020 are here brought together in one place. Pieces are organized into six themes: 1. Necklaces & Sets; 2. Rings; 3. Brooches; 4. Earrings; 5. Bracelets; and 6. Other jewellery forms. The necklaces and sets are further classified into: 1. Colored Stone; 2. Diamond; 3. Fei Cui; 4. Pearl; 5. Opal; 6. Coral; 7. Gold; and 8. Selected Finished Jewellery.

According to a report by 'Global Design Watch,' Taiwan's design competitiveness ranks among the world's top 10. In the four major focal points of international design competitions, namely Germany's iF and Red Dot, America's IDEA, and Japan's Good Design Award, Taiwan's performance in various areas of design has won critical acclaim internationally, and the results have inspired pride. Compared with the rate of award-winning in international competitions, Taiwan's performance in jewellery design is equally brilliant and outstanding.

The authors of the Sketchbook of Jewellery Designs come from all walks of life. The vast majority of them do not have backgrounds in professional art training or a foundation in painting or drawing. Their invested efforts in learning rely solely on the strength of their passion for jewellery art. They have developed their abilities through training in a three-month intensive course, applied the Jewellery Design System for creative inspiration, and after numerous modifications, slowly sketched out their works one line or stroke at a time, shaping their unique styles of jewellery.

As of the present, students of the Jewellery Arts Institute of Taiwan have won hundreds of awards in international jewellery design competitions. More than 50 pieces of jewellery design work have won first prize and have received the sponsorship of renowned jewellery companies from all over the world, and been made into jewellery products, allowing the designs to become real. This is extraordinarily significant, and it is a testimony to the Taiwanese design.

目錄　Content

項
飾
及
套
組

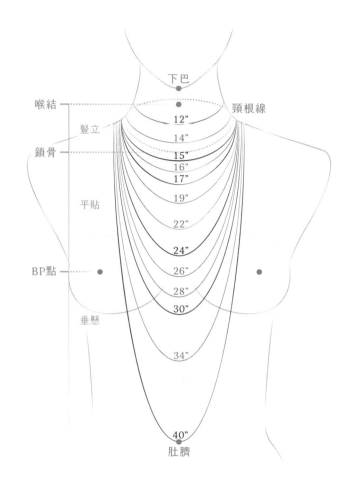

下巴

喉結 ———— 頸根線

豎立

12"

14"

鎖骨 ————

15"
16"
17"

19"

平貼

22"

24"

BP點 ————

26"

28"

30"

垂懸

34"

40"
肚臍

項鍊，是一種穿戴佩掛在頸部的長條鏈狀或環狀裝飾物件。遠古時代，項鍊的出現可能是為了保護脖子，而不是裝飾；可以斷言，佩戴項鍊的行為更早於穿著衣物，又以裝飾項上首級為主，故有「首飾」之稱。

在物質充裕的現代，人類追求自我實踐，講究珠寶與場合的搭配關係，珠寶首飾潛移默化在日常持續發揮效能，演化成八種主要的項鍊形式，環於頸，垂於胸，貼於心，持續觸動著生命。

1 —　頸鍊（Choker）周長約12–14英吋。中譯有「緊、使人窒息之物」的意思，另稱「脖鍊、貼頸鍊、高頸鍊」。頸鍊的整體構造位於

頸根線上端，上頸圍較小，下頸圍稍大，呈直聳挺立狀，類似豎領的形式。貼頸項鍊在許多古文明中都曾出現過，但無論材質種類、結構軟硬，佩戴頸鍊必須契合頸圍，「服貼」才能襯托出優雅氣質。

Peaceful Necta/黃淑儀/頁122

2 — 領鍊（Collar）周長約13–16英吋。中譯有「衣領、領口、項圈」的意思，另稱「衣領鍊」或「頸根鍊」。領鍊造形體積範圍涵蓋在頸根線的上下部位，上窄下寬呈倒喇叭口形狀，穿戴領鍊和頸鍊同樣講究貼身效果，需要量身訂製。此外，因為上頸部位直立，並且受臉頰下巴遮掩影響構成陰暗帶，所以通常刻意增加下圈的造形面積。

繁花似錦/黃淑儀/頁161

3 — 公主鍊（Princess）周長約15–17英吋，穿戴座落於頸根線下端與胸口上端，又分「華麗型」和「輕巧型」。輕巧型是公主鍊的經典代表，細緻小鍊搭配小巧墜飾，常與晨裝穿搭，故又稱 「日間鍊」。華麗型即所謂的短型珠串項鍊或造形稍具規模的短型項鍊。

輕巧型—夏日情懷/邱瓊瑩/頁79
華麗型—印象銀杏/李曉晴/頁94

4 — 瑪蒂妮鍊（Matinee）周長約16–24英吋，中譯為「午後音樂會或一種女裝款式」。穿戴座落於胸口最平坦的部位，提供了極佳的展示環境，幾乎所有「大套鍊」都屬於瑪蒂妮鍊，臺灣傳統婚嫁禮俗中使用的純金首飾為典型代表，十之八九，皆屬瑪蒂妮鍊形式，並多以「倒三角構圖」為造形。

翠竹迎春雪/凌茉青/頁64
雙宿雙飛/李芷彤/頁160

5 — 禮服鍊（Opera）周長約24–30英吋，中譯為「歌劇」，是指出席隆重場合所佩戴的款式。穿戴長懸於乳房半球之間，以乳頭點為界線，又分成「上段」及「下段」兩種型態。「上段型」穿戴後呈現垂貼狀態，「下段型」則偏長越過乳峰，受乳房隆起影響，鍊身呈垂懸狀態，因此偏長的鍊身結構，常以串珠鍊結形式表現。

上段型—日新月異/程采葳/頁98
下段型—瑰麗Magnificent/陳思穎/頁136

6 — 索鍊（Rope）周長約30–34英吋，中譯為「繩」。長度越過乳房低垂，位於罩杯和肚臍中間，長鍊如繩，故有「繩鍊」或「繩索鍊」等稱法。

月鄉思/黃裕雯/頁15

7 — 長索鍊（Long-Rope）周長約40英吋，穿掛後垂懸長度可達肚臍位置，鍊身長度能環繞成「雙圈」模式，故有「結繩鍊」或「長結繩鍊」的稱法。長鍊構造的共同特色是「越長越細」，模組段落小巧，靈活且柔軟。

冬詠/陳虹曲/頁74

8 — Y字鍊（Y-Chain）並無特定長度區別，造形類似Y字而名，屬於倒三角構圖。Y字鍊另有「T字、H字、X字」共四種類型。珠寶設計師通常以「交會處」作為焦點所在。多數Y字鍊呈長鍊的構造，修長的鍊身則越扁平細窄，靈活分段，佩戴時可展現動感。

Y字—Dawn Blossoms/陳芳葵/頁115
H字—漣漪效應/李宛亭/頁38
T字—Share/曾韻茹/頁44
X字—Purity/吳佩容/頁132

剎那的永恆/黃裕雯
2018香港JMA國際珠寶設計比賽
優異獎

「比賽永遠不只是比賽，而是建構新
世界。在教育職場，經常被問及成為珠
寶設計師最大的改變是什麼？答案是
『看見全世界』。這種體會絕對是來自
國際競賽。出國與多國企業和設計師
交流，便深刻的發現自己如何渺小，因
此提醒自己要放大格局，以國際為發
展定位。萌生這樣的思維，是參加國際
珠寶設計比賽獲得的附加價值，卻足
以影響一生處事邏輯。台灣在國際現
實中位居弱勢，每當在國際競賽場合
上，因獲獎宣讀到台灣的那一刻，是如
此的美好！所謂的為國爭光，大概就是
這樣的感受吧。」

蝶舞蘭馨/侯琇玲
2018台灣首屆昇恆昌珠寶設計大賞
優選獎

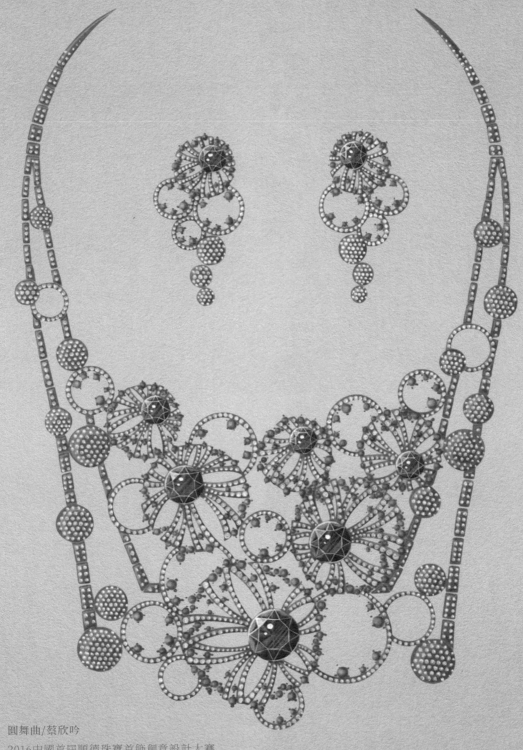

圓舞曲/蔡欣吟
2016中國首屆順德珠寶首飾創意設計大賽
佳作獎

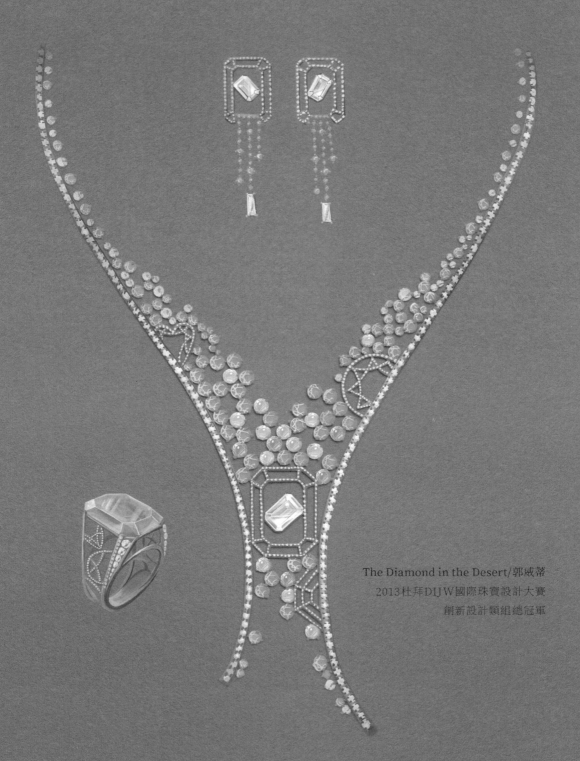

The Diamond in the Desert/郭威蒂
2013杜拜DIJW國際珠寶設計大賽
創新設計類組總冠軍

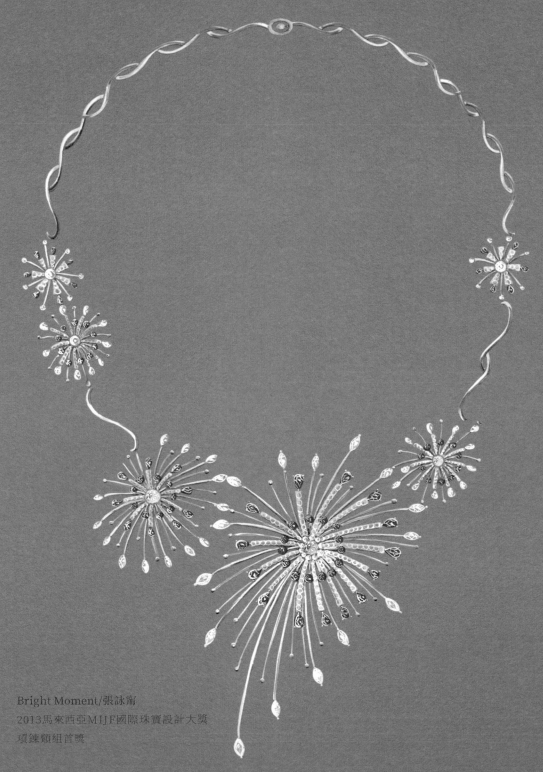

Bright Moment/張詠甯
2013馬來西亞MIJF國際珠寶設計大獎
項鍊類組首獎

月鄉思/黃裕雯
2018中國中和盛世珠寶設計大賽
最佳工藝獎

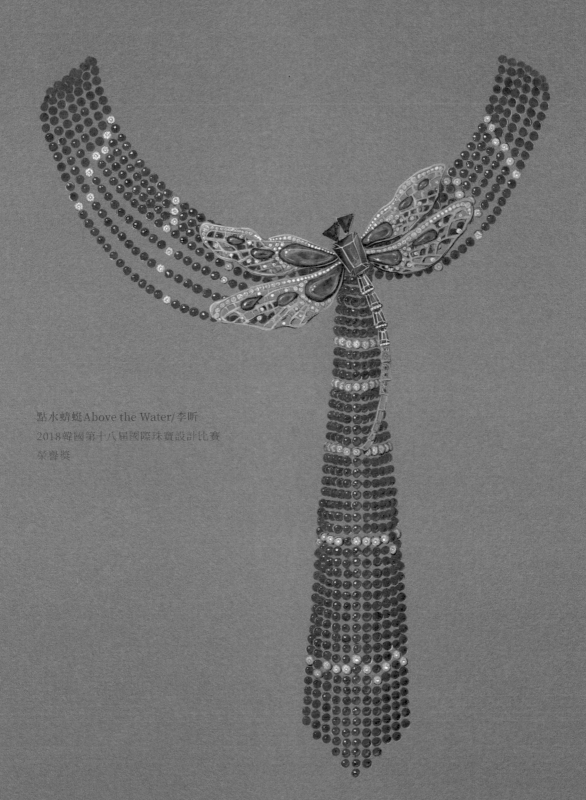

點水蜻蜓 Above the Water/ 李昕
2018韓國第十八屆國際珠寶設計比賽
榮譽獎

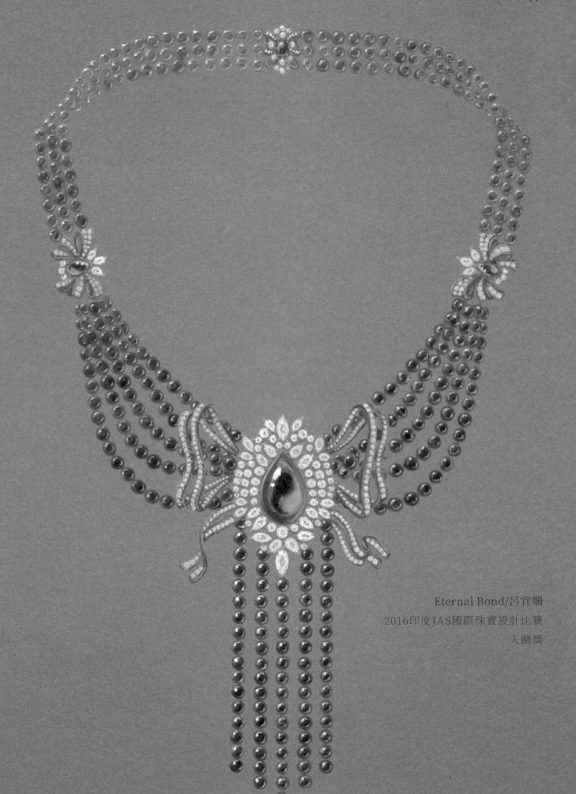

Eternal Bond/呂宜姍
2016印度JAS國際珠寶設計比賽
入圍獎

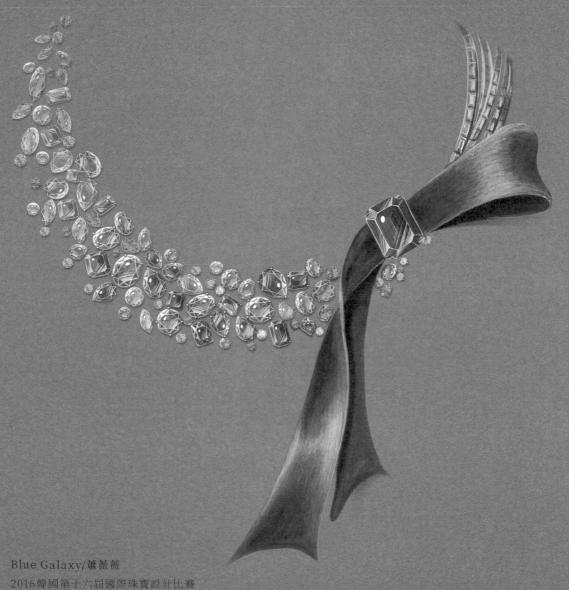

Blue Galaxy/蕭薇薇
2016韓國第十六屆國際珠寶設計比賽
榮譽獎

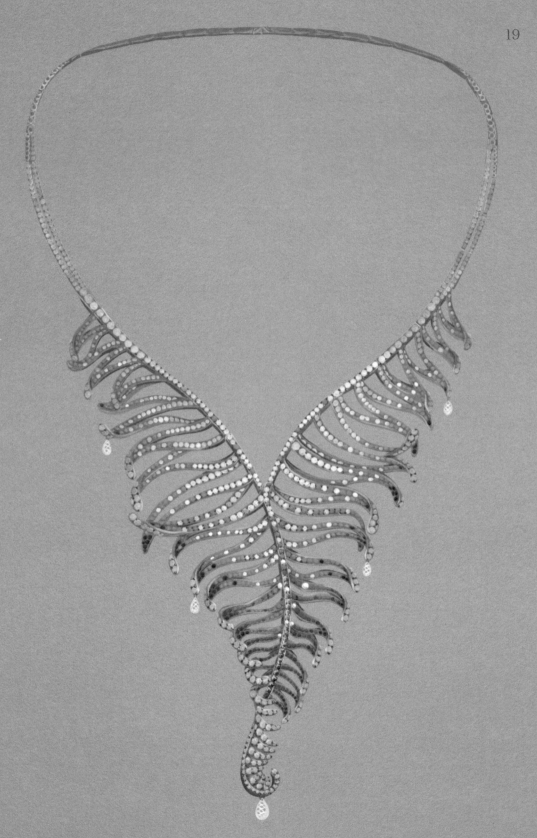

蕨醒／鄭羽軒

耀Match/林秉廉
2016印度JAS國際珠寶設計比賽
入圍獎

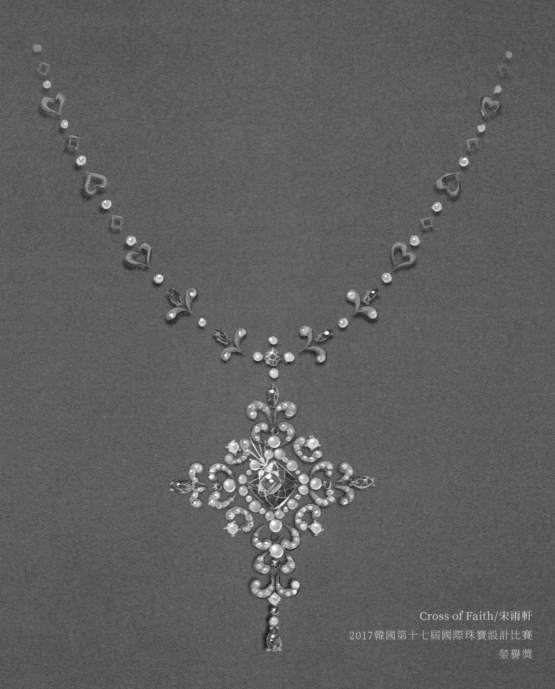

Cross of Faith/宋雨軒
2017韓國第十七屆國際珠寶設計比賽
榮譽獎

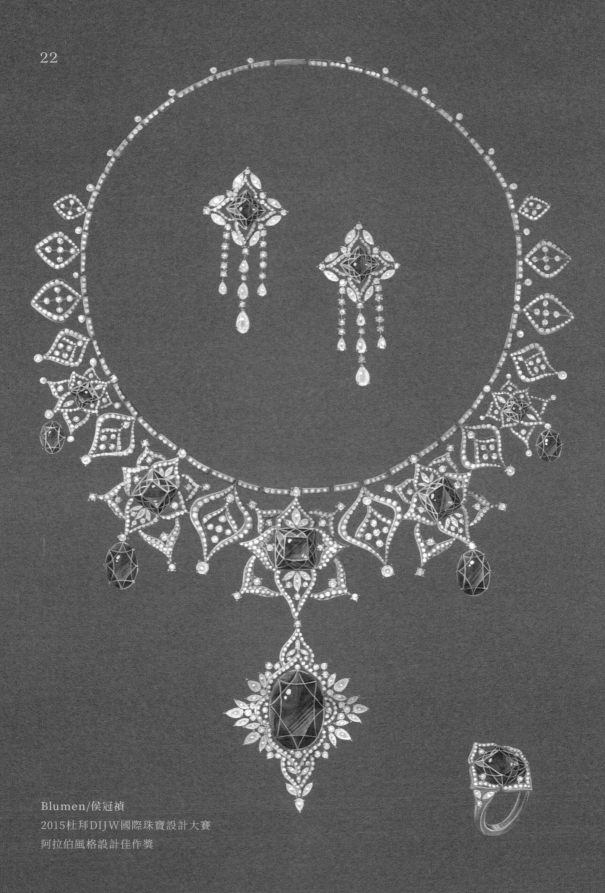

Blumen/侯冠禎
2015杜拜DIJW國際珠寶設計大賽
阿拉伯風格設計佳作獎

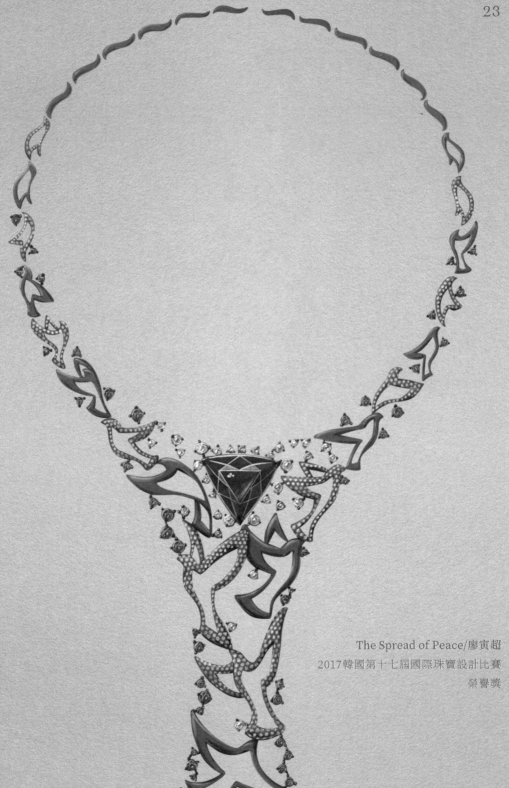

The Spread of Peace/廖寅超
2017韓國第十七屆國際珠寶設計比賽
榮譽獎

Shining Light of Peace/侯琇玲
2017韓國第十七屆國際珠寶設計比賽
卓越設計師獎

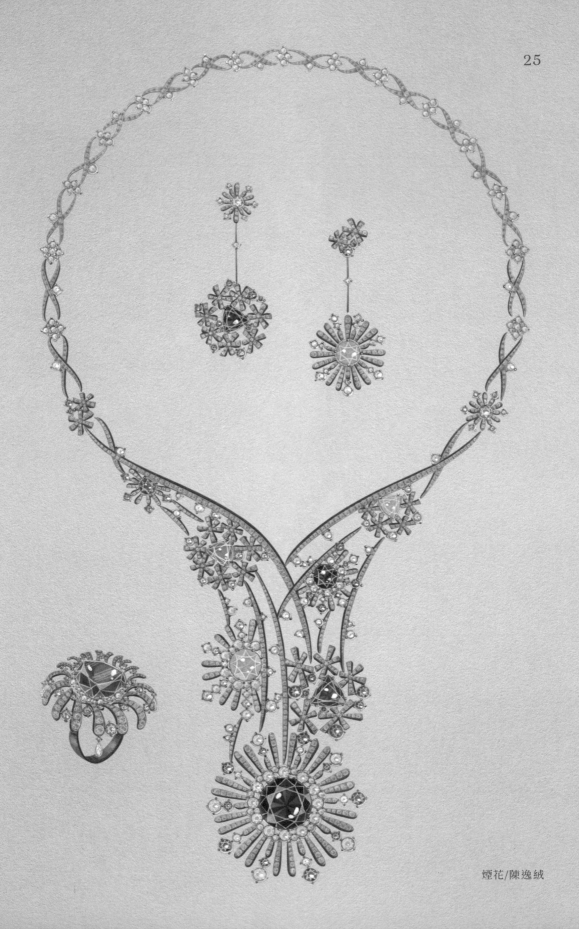

煙花/陳逸絨

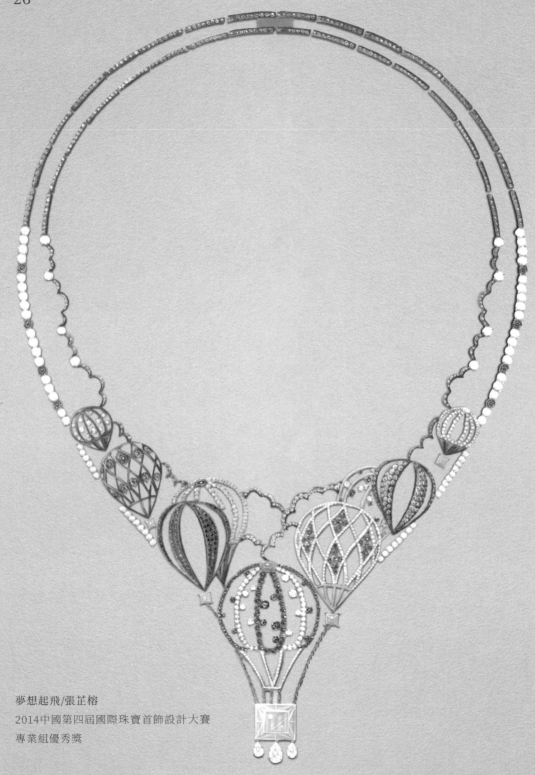

夢想起飛/張芷榕
2014中國第四屆國際珠寶首飾設計大賽
專業組優秀獎

青華China/鄭羽軒

「素胚勾勒出青花,筆鋒濃轉淡。瓶身描繪的牡丹,一如妳初妝。如傳世的青花瓷自顧自美麗。青花在素白瓷胎上發藍,是鈷釉料陶冶窯變後產生的永恆青藍色澤,一種獨自的高雅,流露著潔淨的古典風韻。元代傳世的青花瓷數量極為稀少,件件為國之重器。

藍寶石為火成岩經歷了萬年的變異生成,猶如千度高溫的冶煉生色,青花寶藍色相近似藍寶石,恆藍色澤歷久不衰。愛上青花瓷瓶收口歛腰的玲瓏標緻,特以為設計主題,結合盛綻的牡丹花嬌,雍容華貴展現『陶瓷母邦』的傳統工藝文化美好,將天青釉私藏的東方風韻,體現在珠寶首飾,展現在膛頸之上,隔江千萬里,遙寄元朝古代的一縷飄逸。」

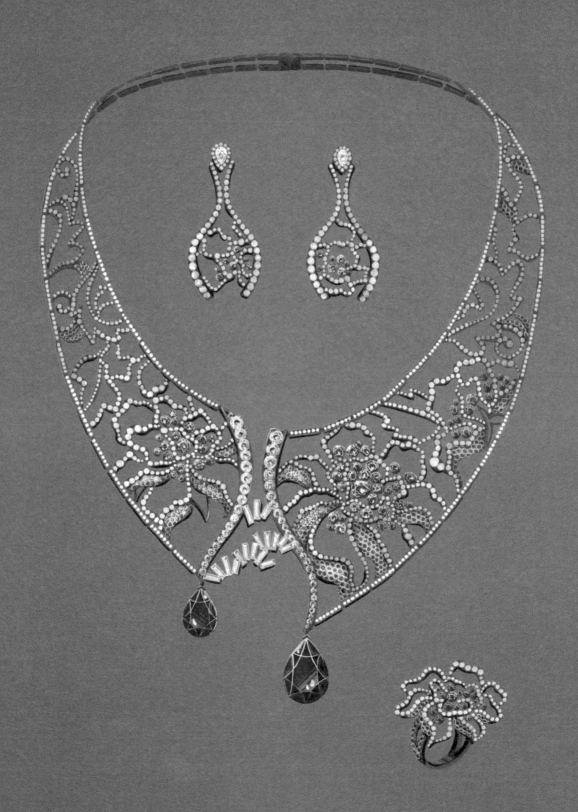

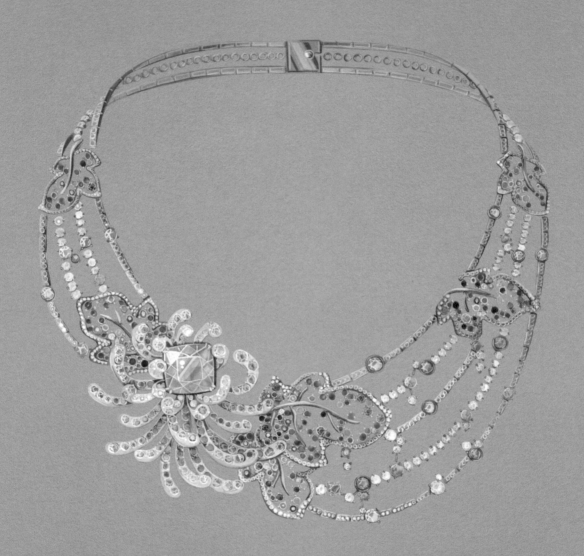

芳菊向煦/吳祝銀

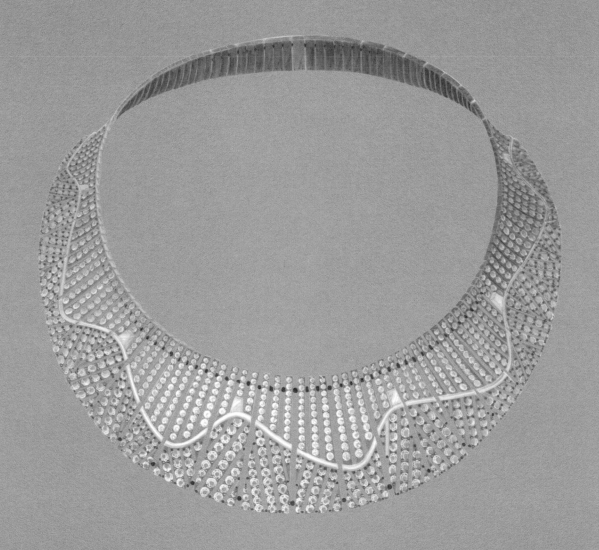

萬里長城/蔡宜軒

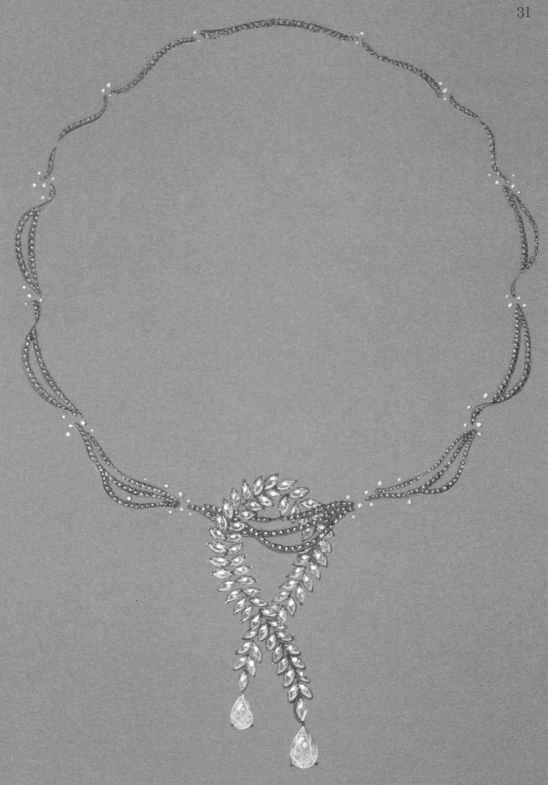

穗時紀/阮齡萱

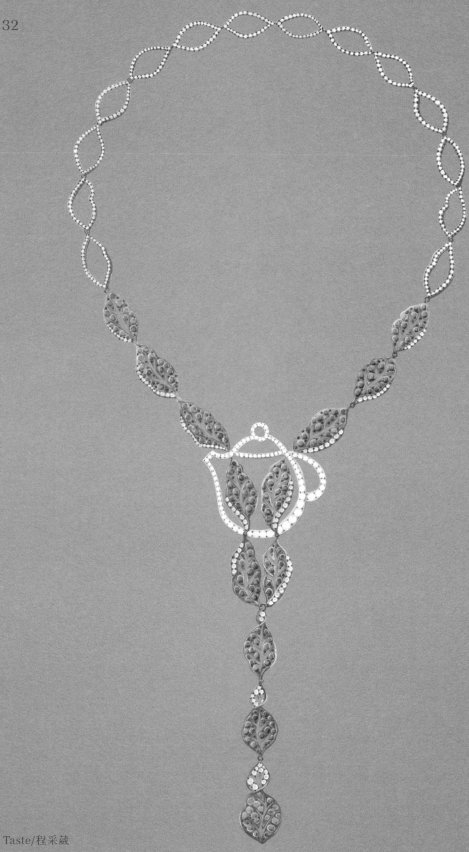

Taste/程采葳

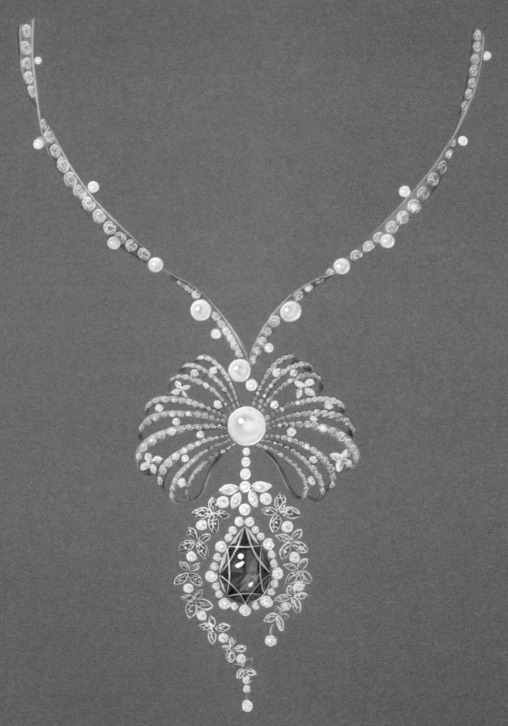

Charm/莊喬鈞

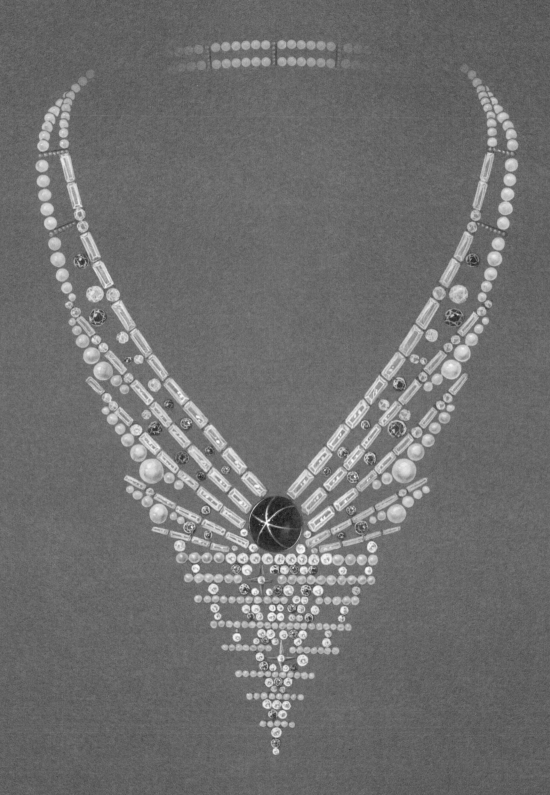

Sunny/李佳菱

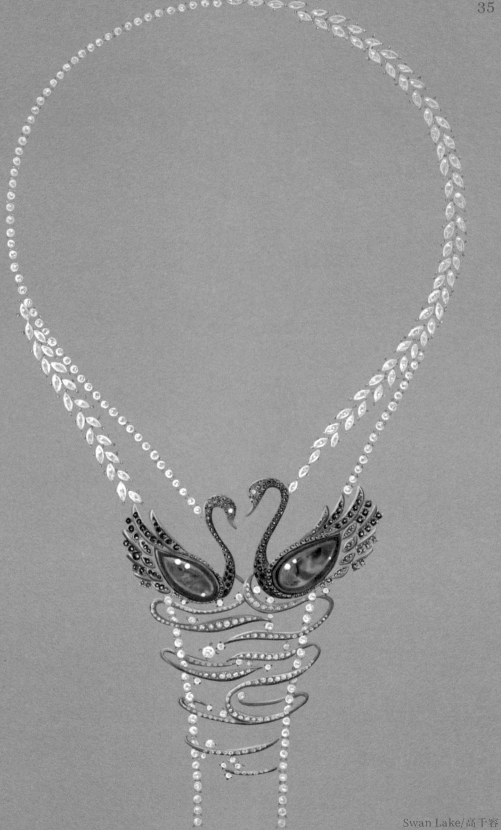

Swan Lake/高千容

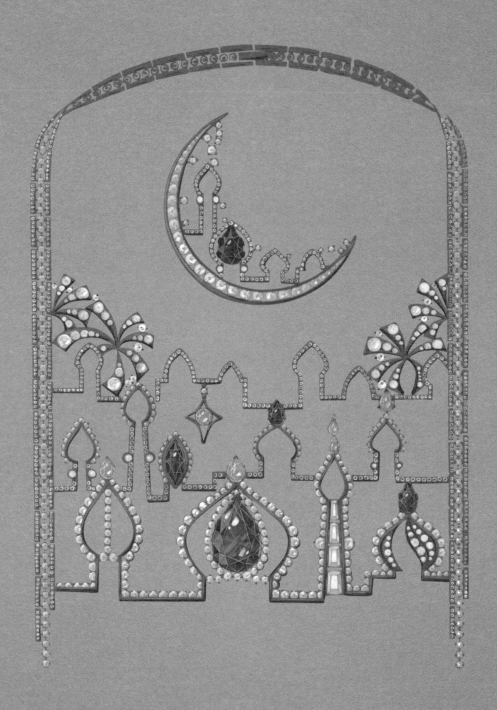

Good night/陳逸絨

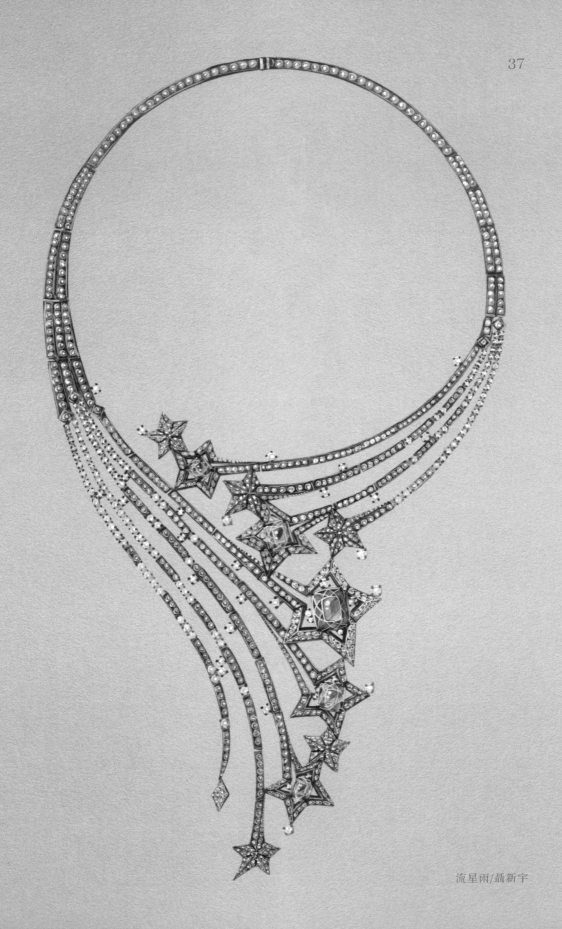

流星雨/聶新宇

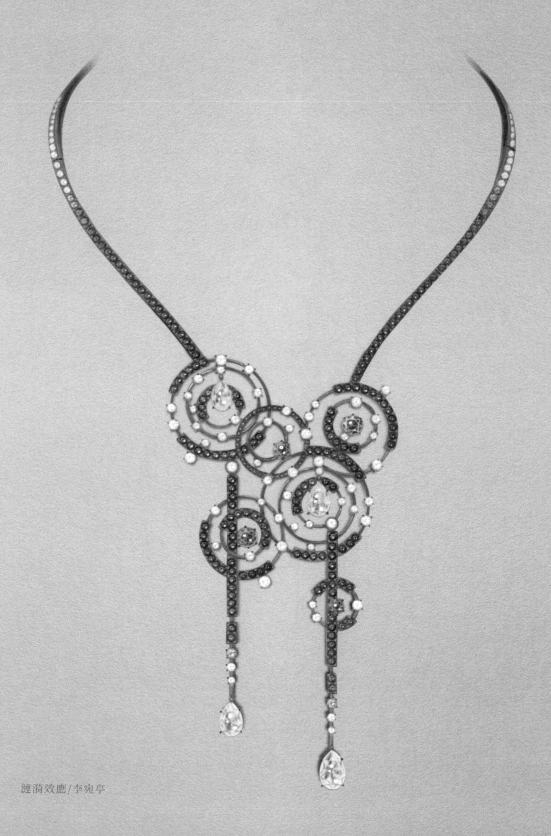

漣漪效應/李宛亭

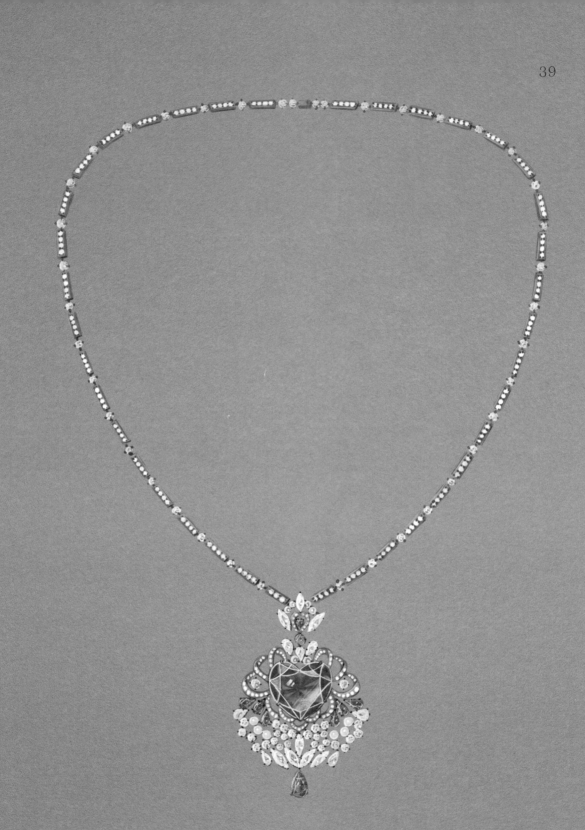

綺麗蔚藍/陳思穎

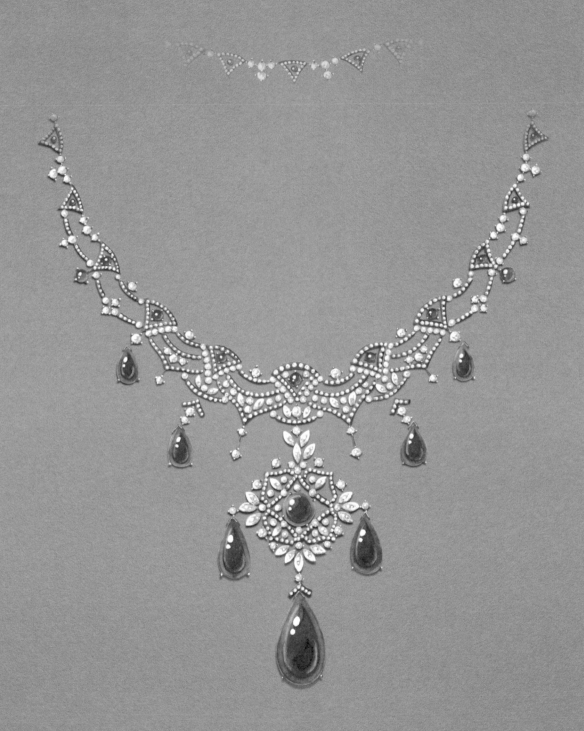

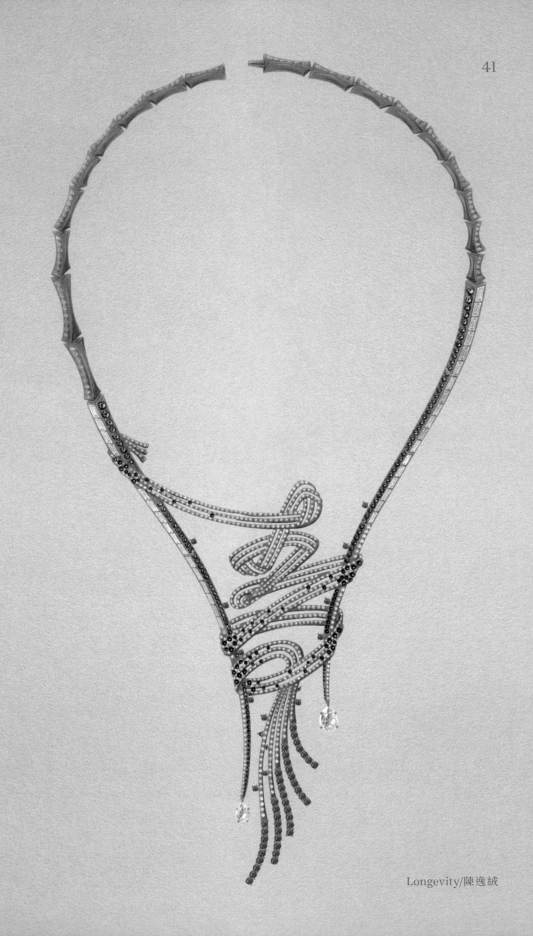

Longevity/陳逸絨

鶴之心/呂宜姍

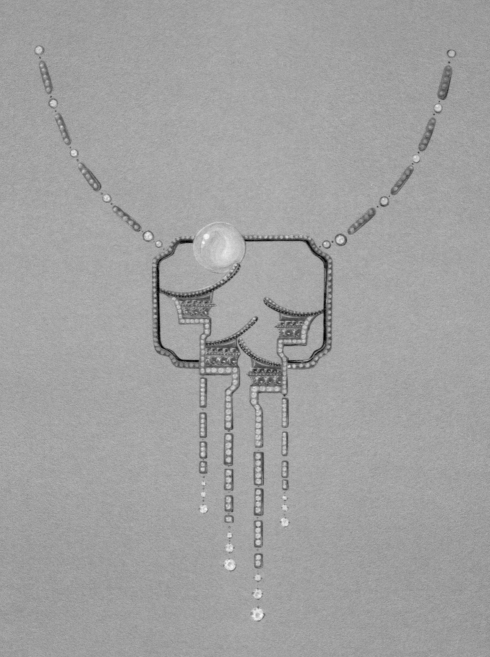

水鄉秋月/殷璐妍

鑽石

Dispersed of Love/呂宜姍
2017韓國第十七屆國際珠寶設計比賽
榮譽獎

「我對新鮮事物充滿好奇，迷戀一切
和美有關的事物。從事金融投資，在工
作之餘將私人興趣延伸至珠寶領域，
成立了美丸珠寶工作室，將產品注入
溫度與靈魂，創造最純粹的美，享受著
珠寶訂製與銷售服務帶來的成就感。
多年下來，不斷積極參加國際競賽，很
榮幸能獲得眾多國際大獎的肯定。

這件作品以愛與和平為設計主題，使
用閃閃發光的鑽石來描繪蒲公英種籽
因風而起的爆發瞬間。種籽乘著風傳
遞生命的希望，一串心形的葉子，訴說
著當我們努力傳播愛與希望的種子，
世界將會更加美好的意念。透過巧妙
安排不同形狀鑽石的位置，創造出立
體與動感兼具的視覺饗宴。」

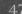

善變的玫瑰/呂宜姍

48

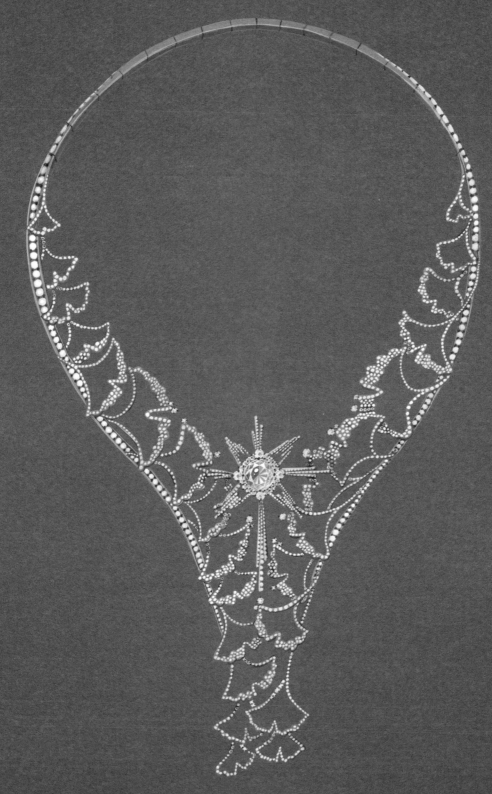

綻・光/陳怡潔

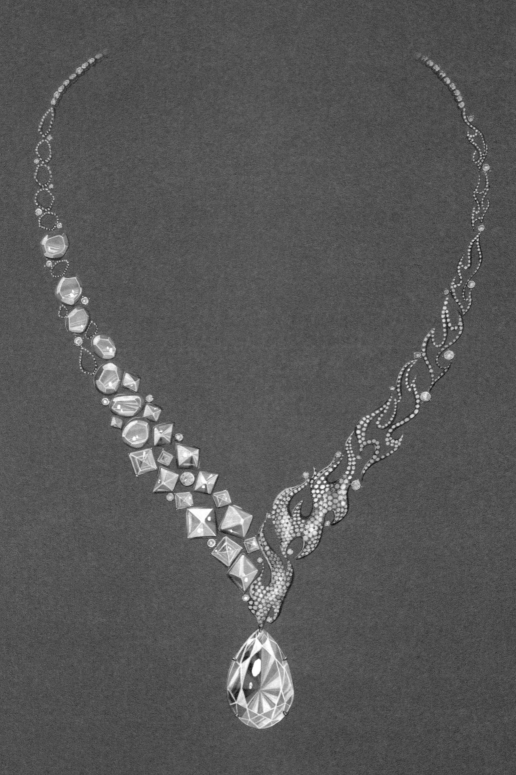

凝煉/陳怡潔

希望之鴿/王皓正, 廖淑芬

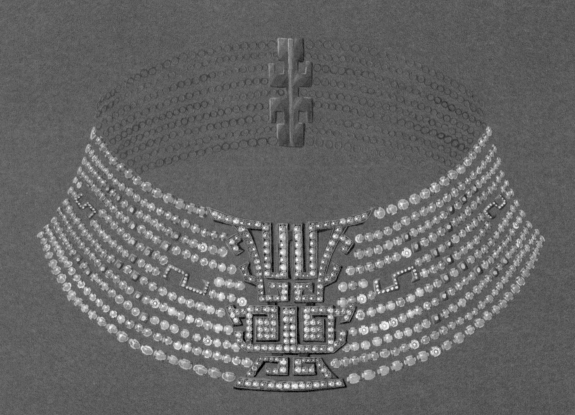

周禮尊重／高佩德

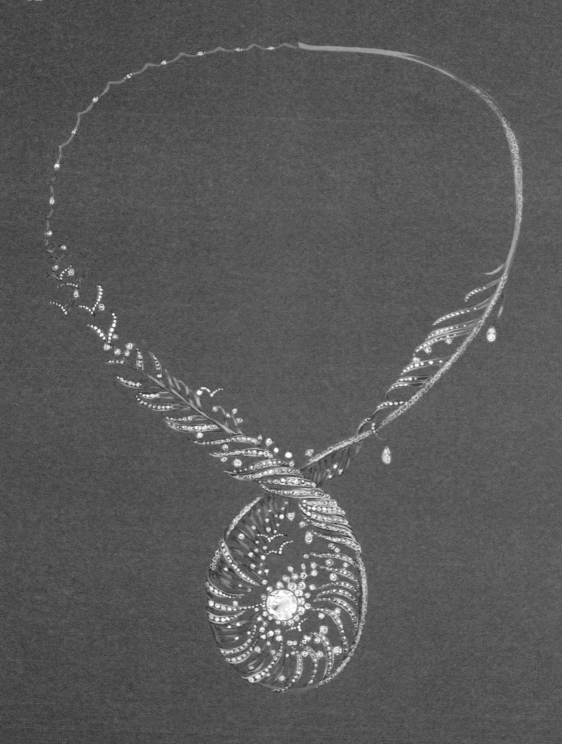

吉光片羽/黃裕雯

玫瑰園Rose Garden/陳奕均
2016中國首屆玉瑤獎首飾設計大賽
佳作獎

「天馬行空的想像，叫做創意；肆意縱情的表現，稱為藝術。設計以人為本，在藝術和創意之間，用講究的態度去為人服務。設計是否成熟，並不只是圖畫得好看而已。想要創造出真實立體的珠寶首飾，就必須充分把握住隱藏在設計圖中的工法結構。

賞心悅目的圖樣，背後倚賴的專業素養和付出的勞力，是難以形容的。從靈感發想、資料蒐錄、解構重組，無論是用手繪表現技巧或是電腦繪圖，都必須將專業智能統合應用。唯有熟練才能隨心所欲，讓設計兼備創意和藝術價值。」

54

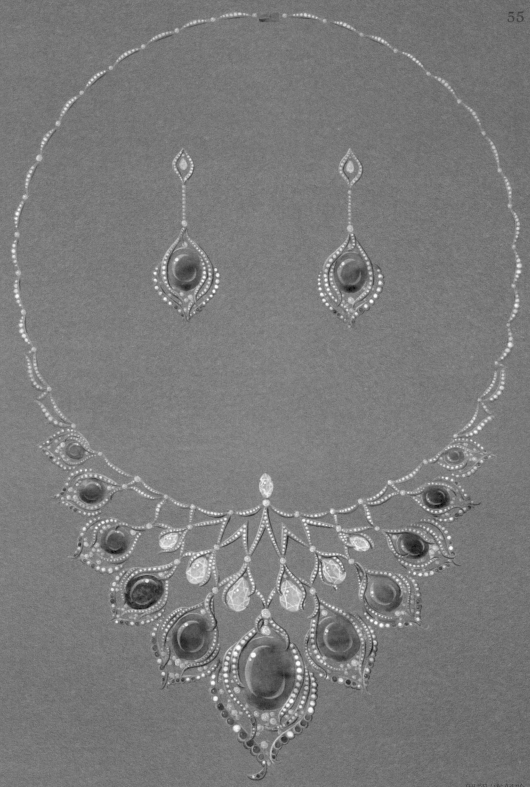

翱翔/盧佩昐
2015中國第二屆印象孔雀珠寶設計大賽
網路人氣獎

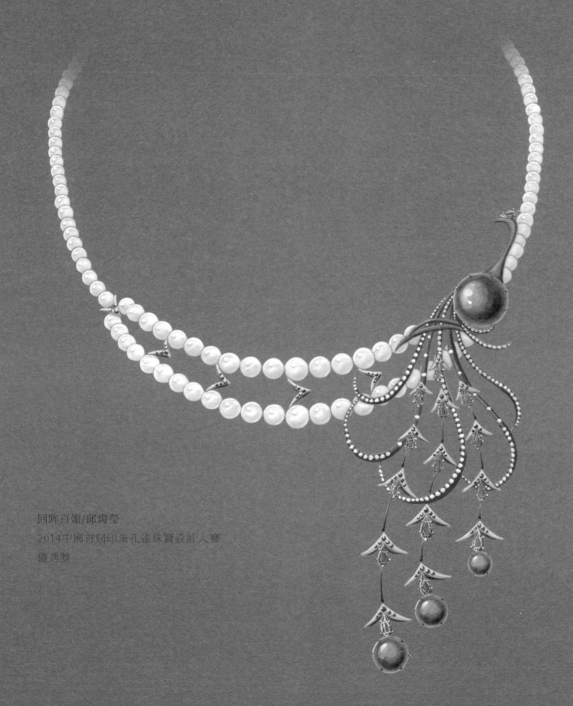

回眸百媚/邱瓊瑩
2014中國首屆印象孔雀珠寶設計大賽
優秀獎

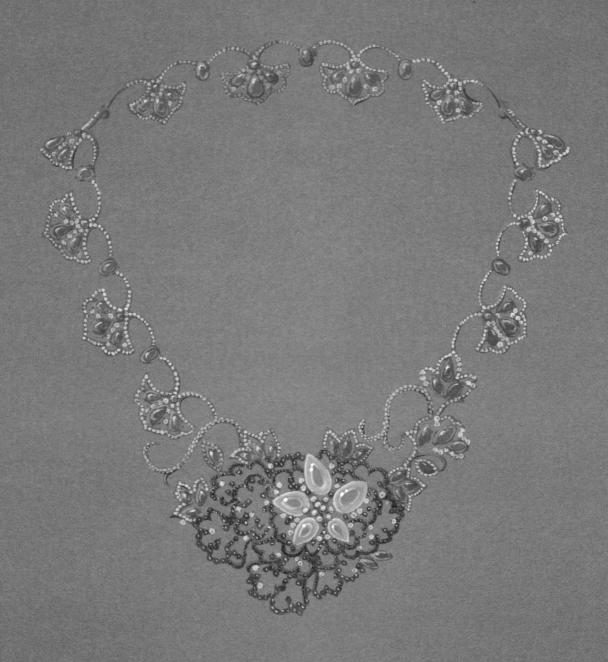

待嫁/呂宜姍

燕歸春至/蔡欣昤
2019香港翡翠創作雙年賽
佳作獎

龍鳳呈祥／黃雯琪

雀屏一展 微視群倫/徐若華
2015中國第三屆印象孔雀珠寶設計大賽
網路人氣獎

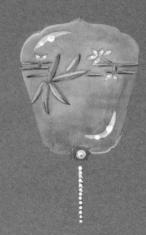

舞衫歌扇/張如卉
2016中國首屆玉瑤獎首飾設計大賽
新秀獎

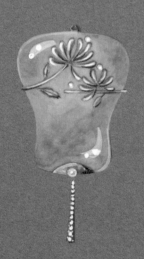

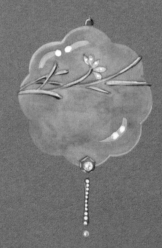

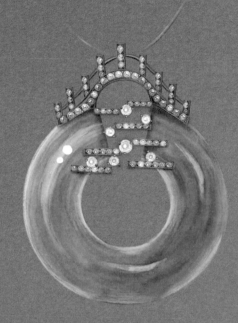

橋韻/陳昱璇
2016中國首屆玉瑤獎首飾設計大賽
職場裝三等獎

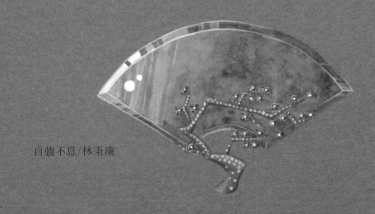

自強不息/林秉廉

翠竹迎春雪/凌茉青

「歲寒三友－竹，在中華民族文明中象
徵君子的情操－虛心長青、高風亮節、
百折不回。竹的堅忍特性，正如翡翠的
剛韌特質，無論從形式內容，或以物質
精神，應用在珠寶首飾設計上，最能體
現、引帶出中國珠寶文化美學哲理。

玉不琢，不成器。設計特色在應用翡翠
玉石的各種『形』和『色』，鉻元素致
色成：墨綠、陽綠、翠綠、黃綠，簇聚
成林，覆葉的碎鑽如霜雪般晶瑩，嵌入
翠綠沙佛萊石，寶石以明亮切割式對
比光面切磨式，在歲末冬夜之季，映照
一幅中國風雅情愫。」

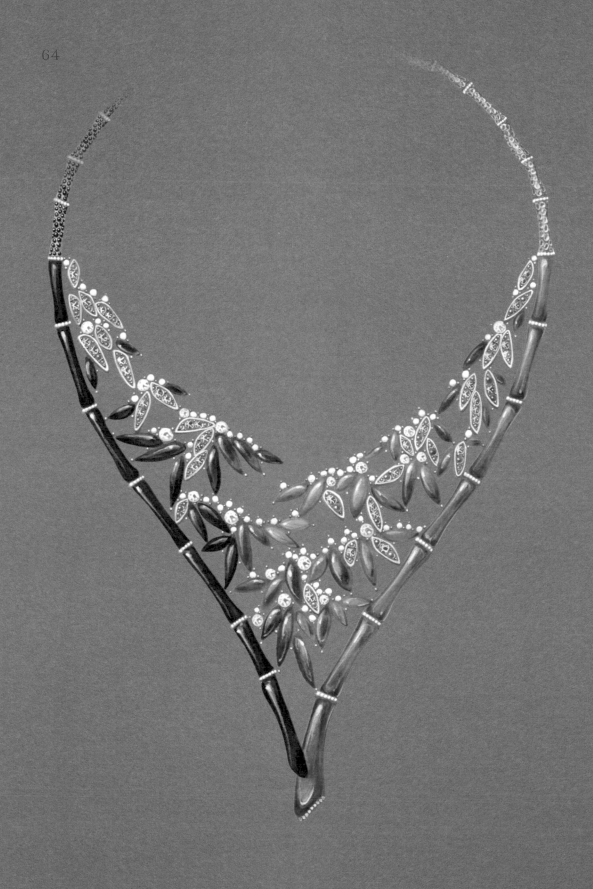

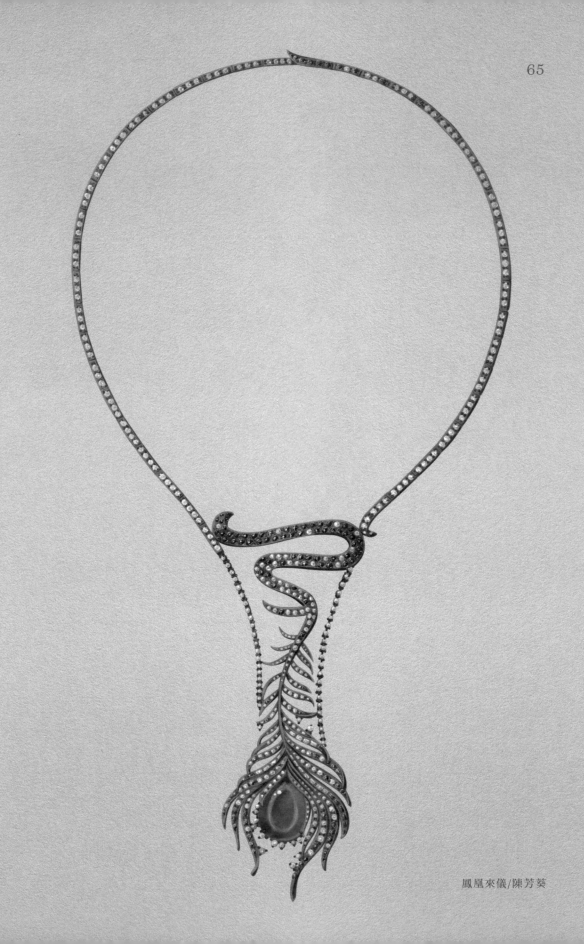

鳳凰來儀/陳芳葵

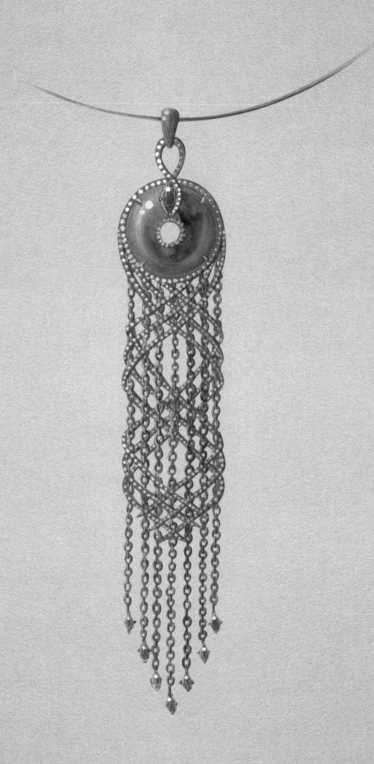

宓/賴季君

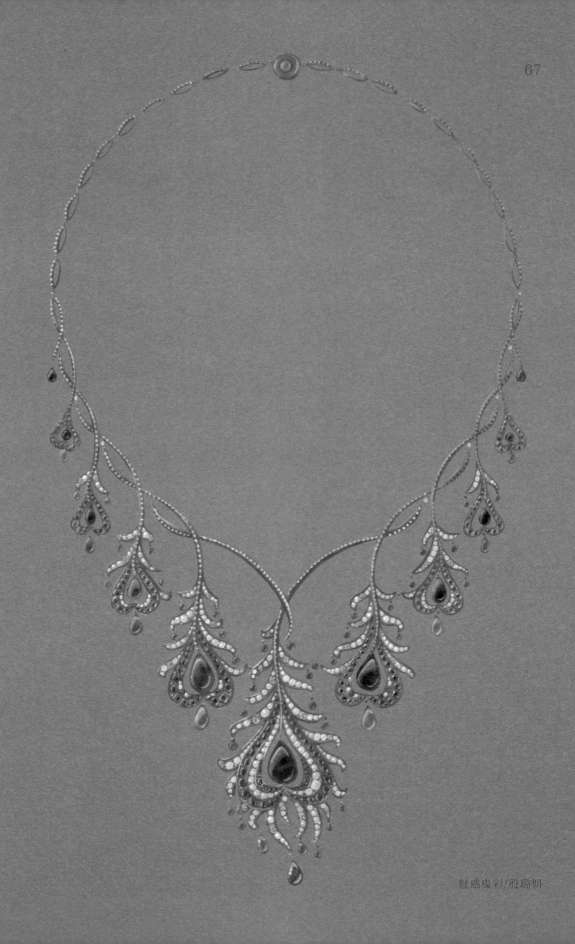

魅惑曳彩/殷璐妍

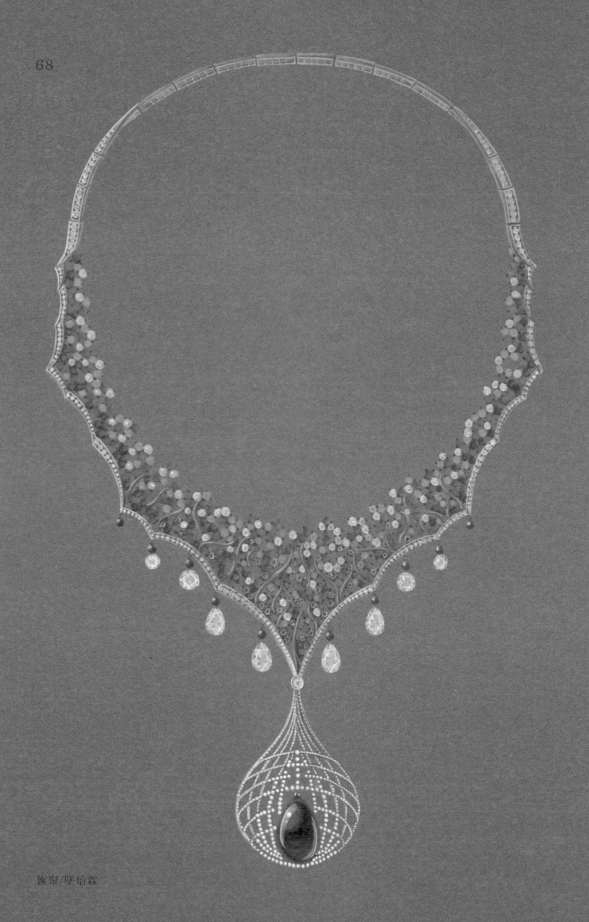

匯聚/璧怡霖

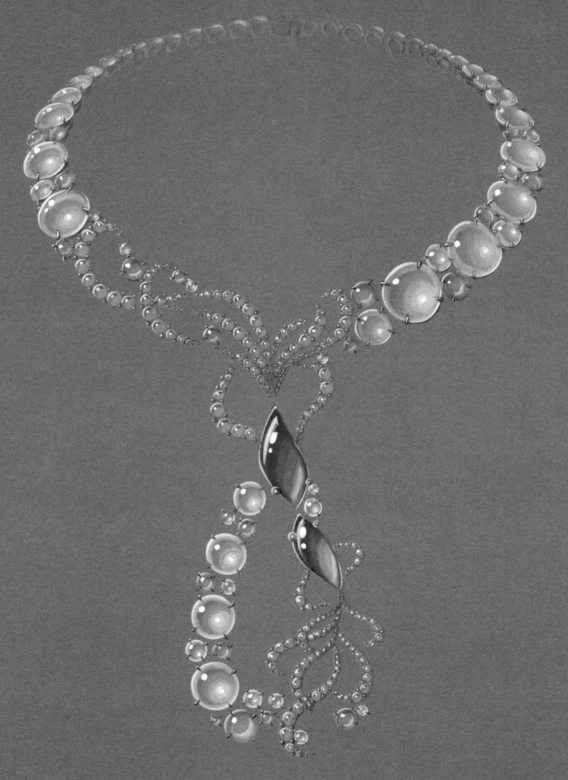

邂逅/廖寅超

秘境/陳盈盈
2014上海國際首飾設計大賽
最佳工藝製作獎

成品/頁208

*潺潺流水*Murmuring Stream/蔡宜軒
2016美國國際珍珠首飾設計比賽
總冠軍

成品/頁192

「圓潤的大珠小珠串落,恰似徐徐水潤潤,*潺潺*流如簾,粼粼漾開的小鑽閃爍,錯落有序的點綴在紅粉珍珠彩暈之間,曼妙曳動的串珠流簾,別緻的漸層在行列演進齊了全,欲去還留。

『昔時嬌玉步,含羞水榭邊。』這文字訴說了美人姍姍徐步的姿態,我將這畫面寄情於這件作品;應用瑪蒂妮項飾的形制,設計將造形由方轉化為圓,大器方成的型態,小巧圓滿的內容,並運用多重對比形式的手法,希望在現代新潮中寄存了幾分古典,讓東方風韻在當代和傳統交融中顯現。」

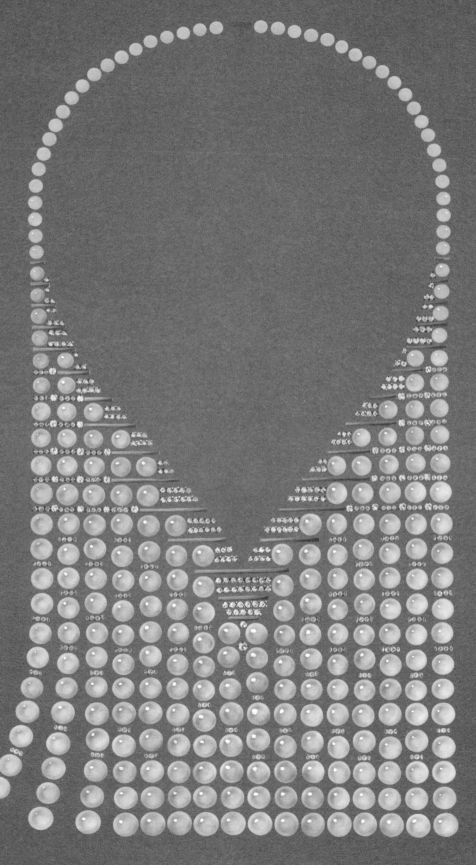

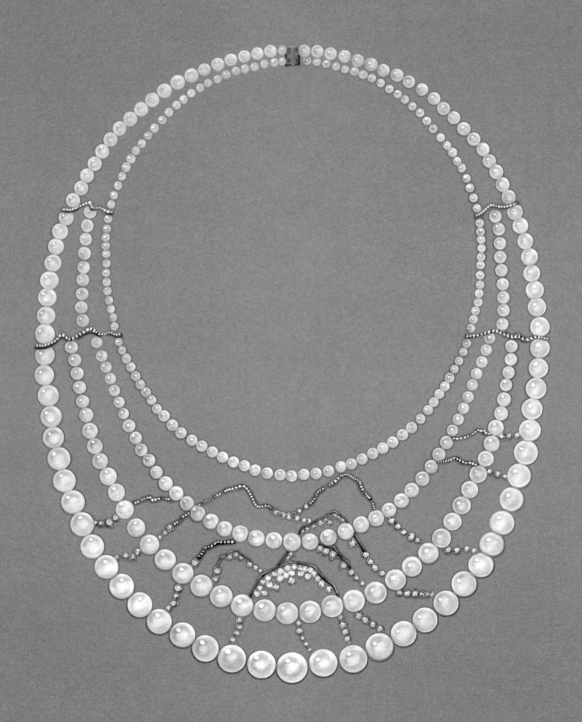

千里江山在雲間/黃裕雯
2018中國山下湖珍珠首飾創意設計大賽
優秀獎

74

冬詠/陳虹曲
2016中國首屆國際珍珠首飾設計大賽
佳作獎

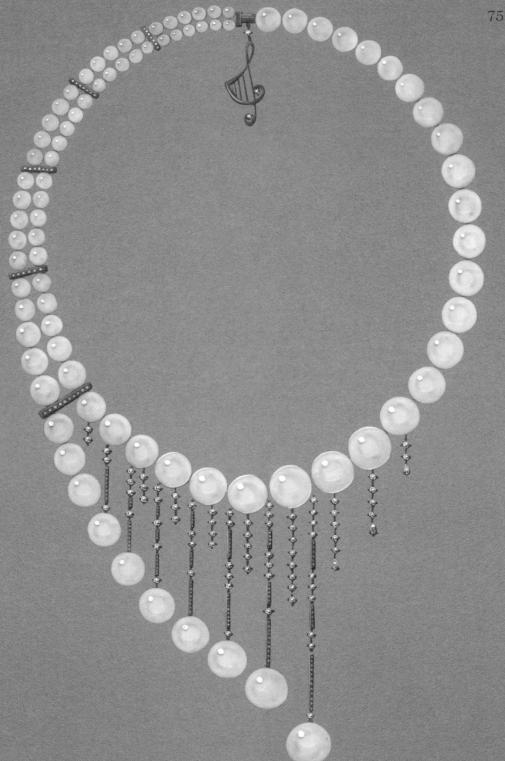

訴情/林秉廉
2016中國首屆國際珍珠首飾設計大賽
佳作獎

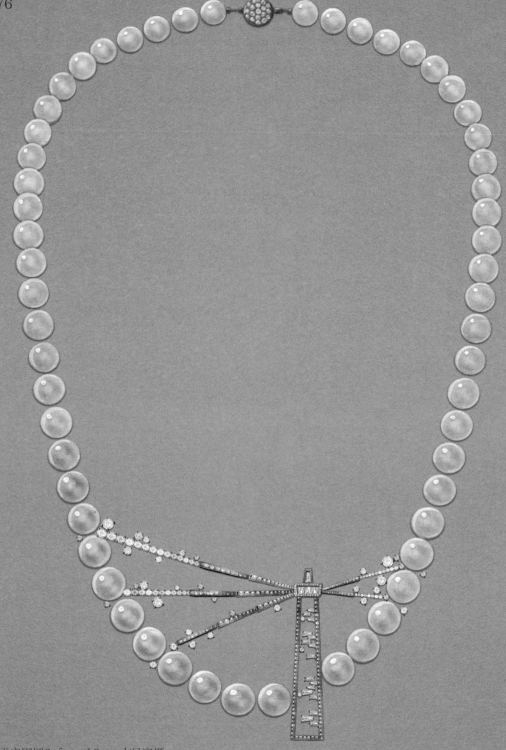

平安團圓Safe and Sound/呂宜姍
2016美國國際珍珠首飾設計比賽
最佳視覺大獎

成品/頁194

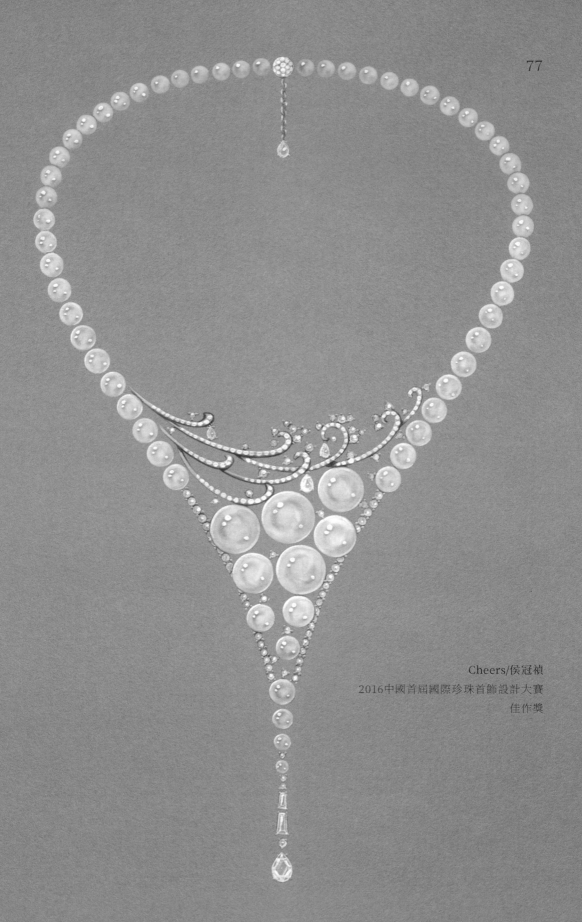

Cheers/侯冠禎
2016中國首屆國際珍珠首飾設計大賽
佳作獎

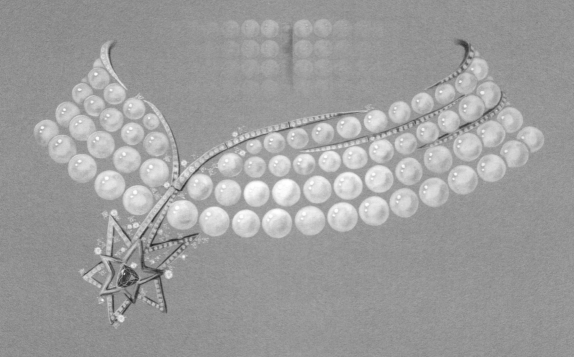

水流星/盧佩吟
2016中國首屆國際珍珠首飾設計大賽
二等獎

成品/頁190

夏日情懷/邱瓊瑩
2013香港第九屆國際南洋珠首飾設計大賽
公開組優選獎

成品/頁196

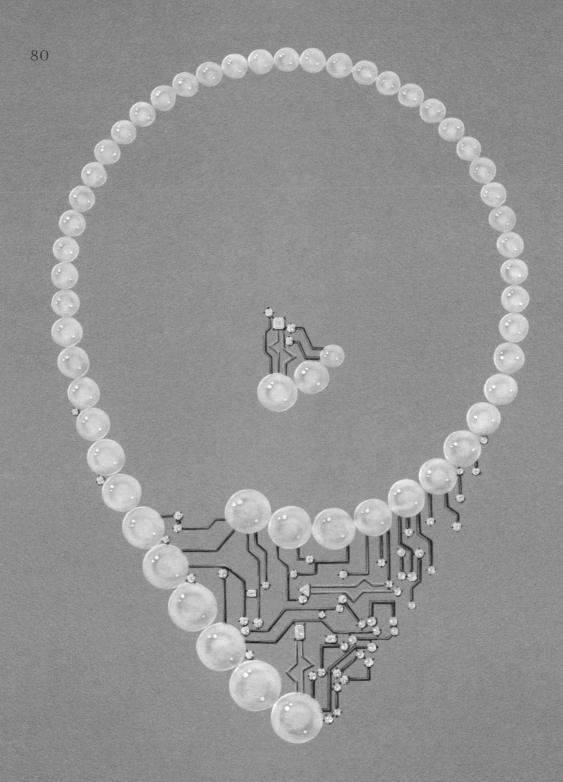

珠戀TrueLove/陳芳葵
2016中國首屆國際珍珠首飾設計大賽
佳作獎

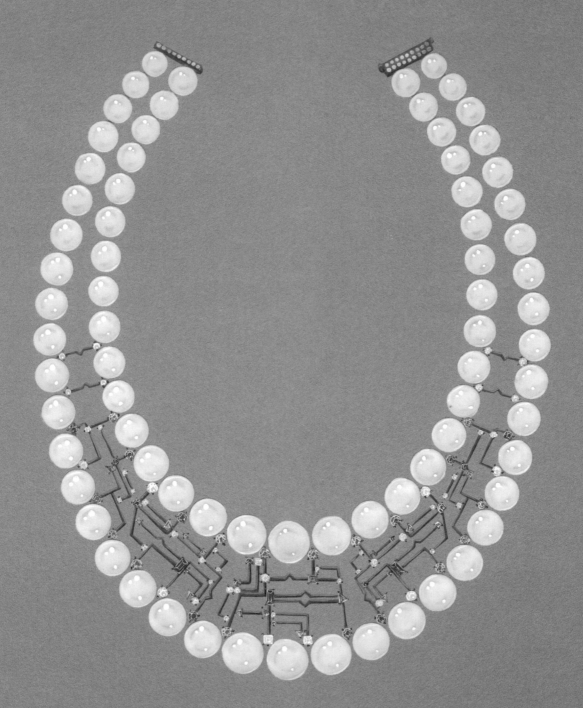

IC臺灣/陳可榆

2018台灣首屆昇恆昌珠寶設計大賞優選獎

與網路人氣獎

珍藏Cherish/蔡宜軒
2013中國第三屆國際珠寶首飾設計大賽
二等獎

成品/頁198

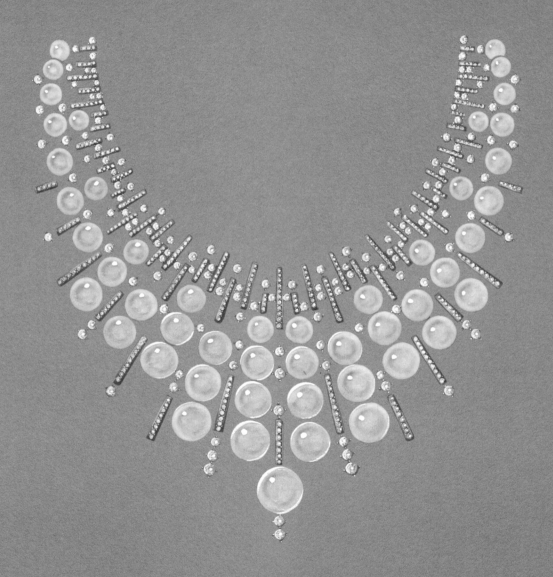

Moonlight Fall/張承皓

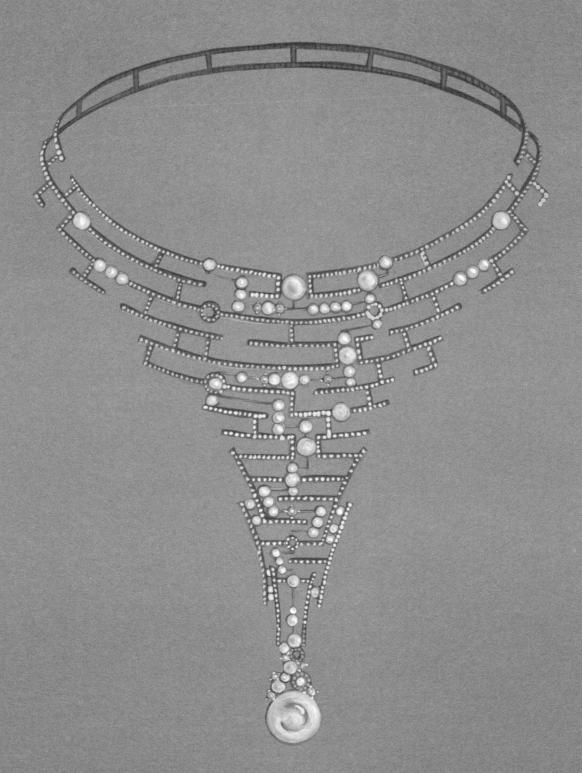

The Maze/陳翊凡

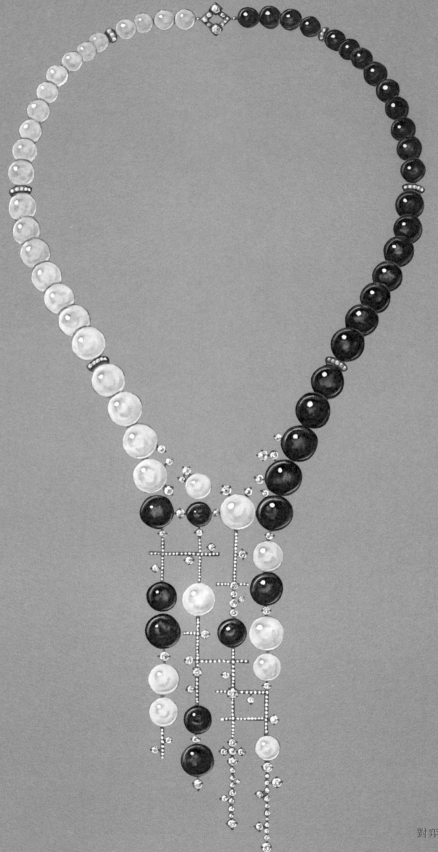

對弈/林恩汎

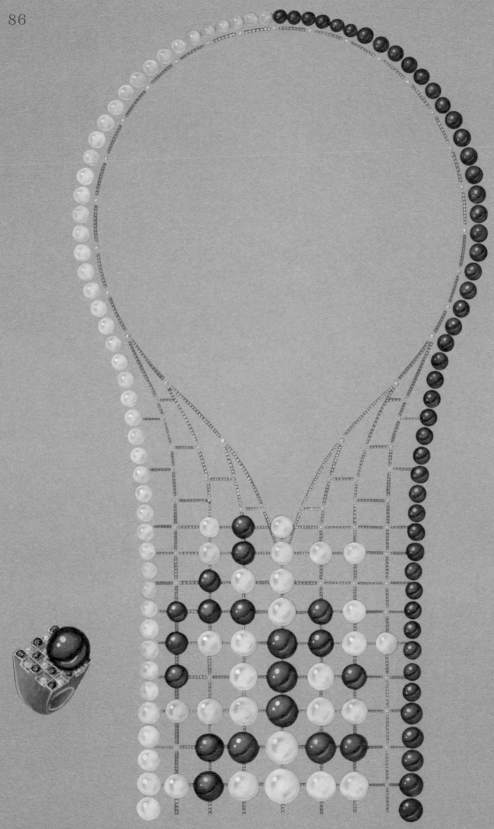

HumanGo/阮齡萱

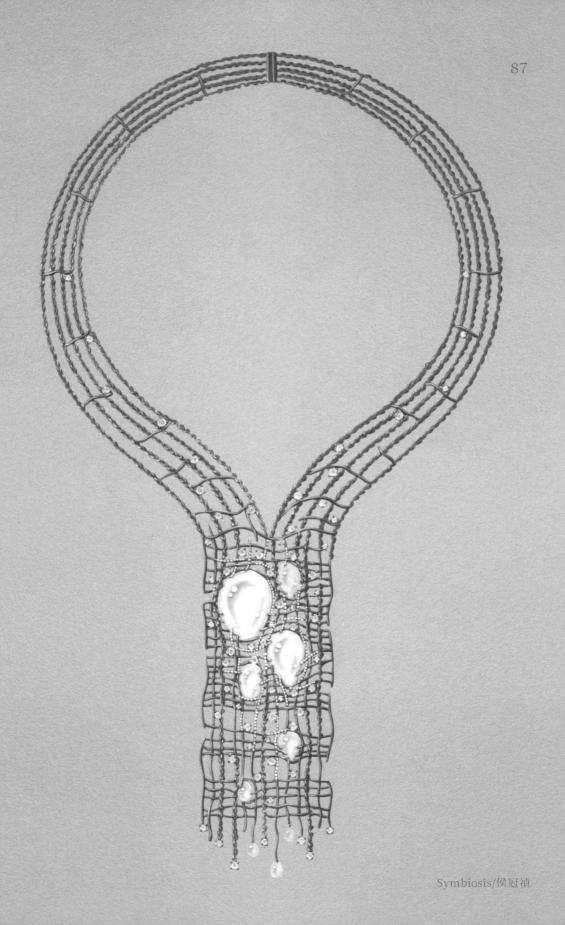

Symbiosis/侯冠禎

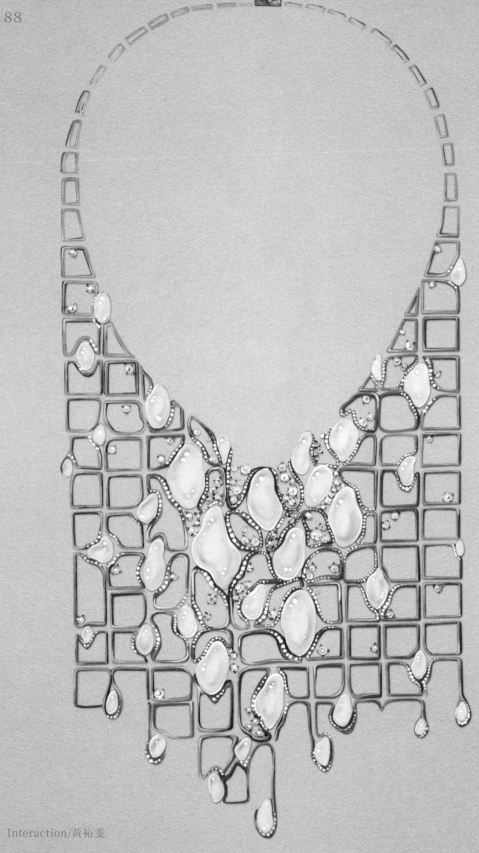

Interaction/黃裕雯

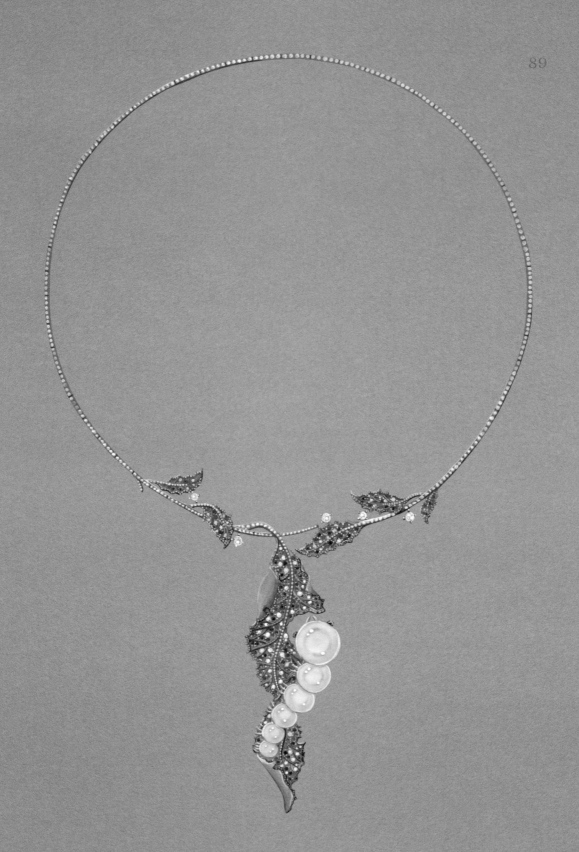

Caterpillar/張如卉

耀動/蔡宜軒

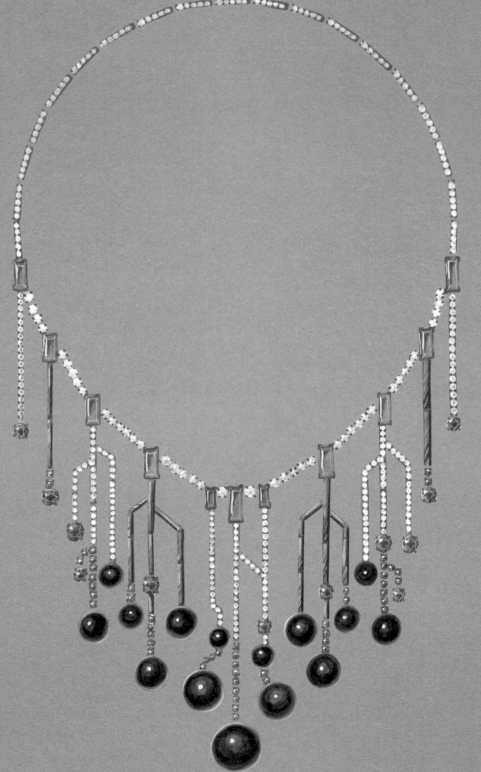

Digital Position/高佩德

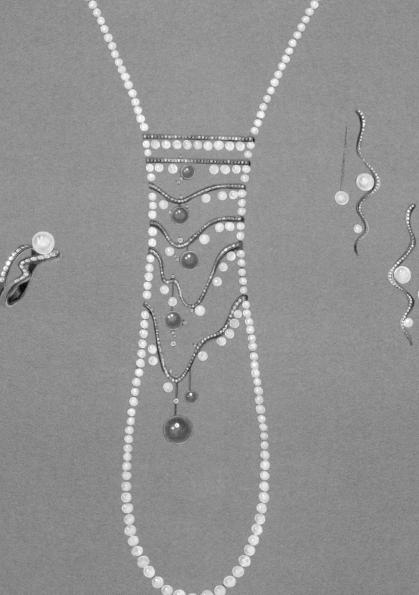

Flowing Vision/黃裕雯

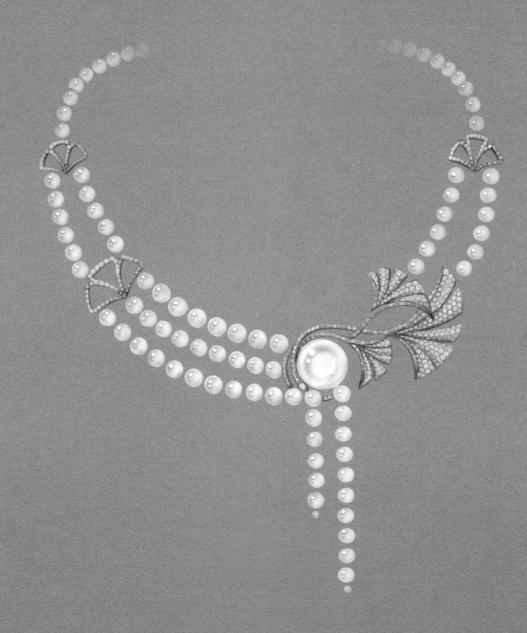

印象銀杏/李曉晴

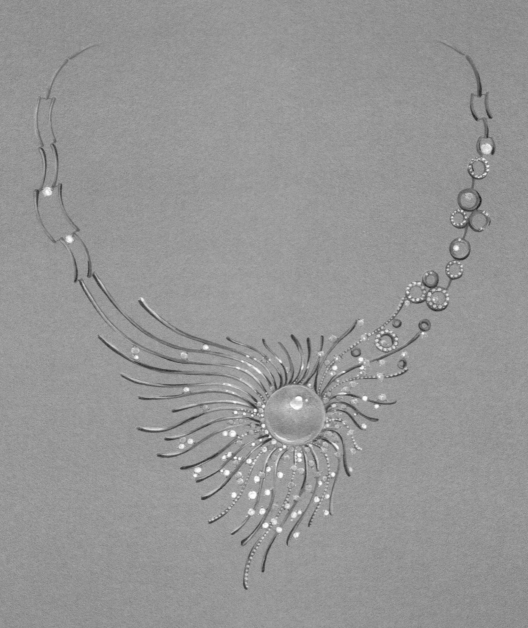

Day and Night/張詠甯

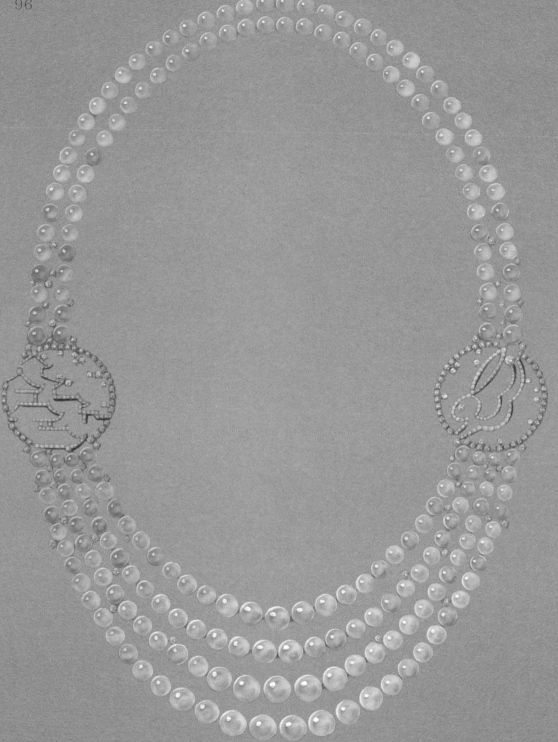

Moon Festival/李曉晴

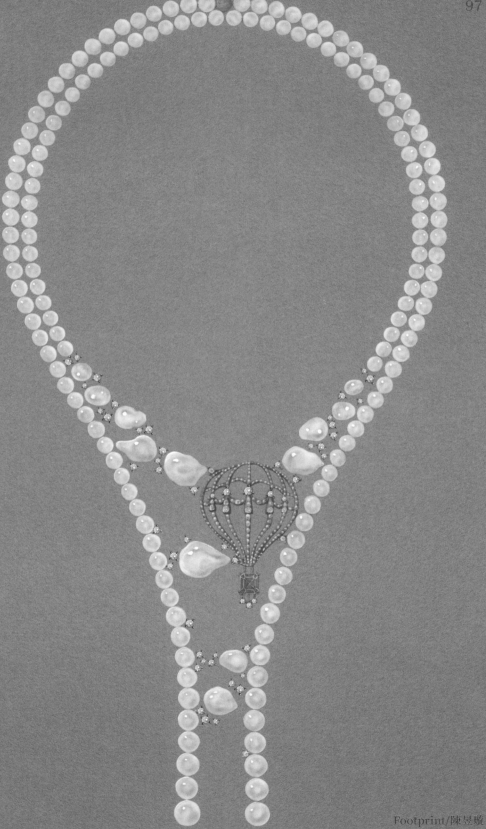

Footprint/陳昱璇

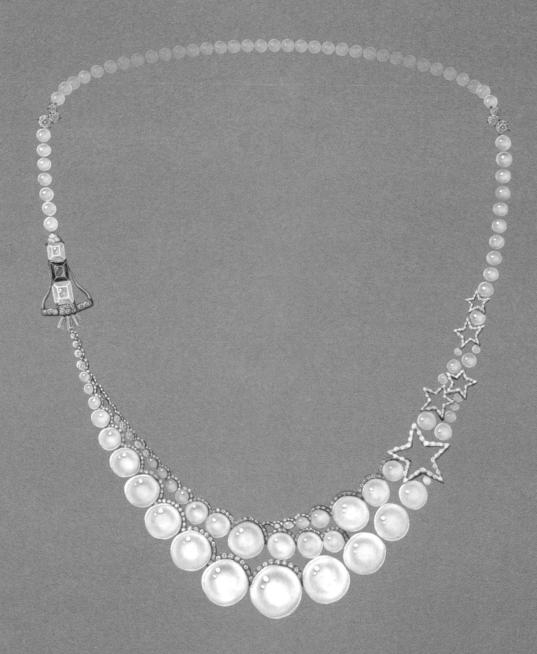

日新月異/程采葳

歐泊 Opal

Lifting Spirits/張如卉
2015澳洲國際歐泊珠寶設計比賽
傑出設計獎

「非美術設計科班，家裡也不是開珠寶店，這樣的背景，在同學之中很常見。我專科唸護理，插大轉心理學，在市調公司寫統計程式做資料處理分析，又轉行寫電腦程式，成為軟體工程師。踏進珠寶業是個美麗的意外，我參加了為期三個月的珠寶設計專業課程訓練，結業後又用了三年時間參加國際比賽來磨練自己的審美眼光、繪畫手感和培養對工法工序的敏銳度。

我喜歡數字，因為數字會說話。個人得獎作品22件，珠寶設計製造委託案超過100件。乍看有點不可思議，但對學院卻是平凡日常。我們不是靠『靈光一現、天降奇蹟』的設計師，而是每天重複一直做、一直畫的一群普通人。一張設計圖修改超過100次，一件水彩完稿花了8小時，是同學們的共同經歷。我們有共通的設計語言、相同的觀念，就像一段別人寫的程式碼擺在眼前，彼此一看都懂它的邏輯運算、知道如何除錯，讓程式效能更優化。」

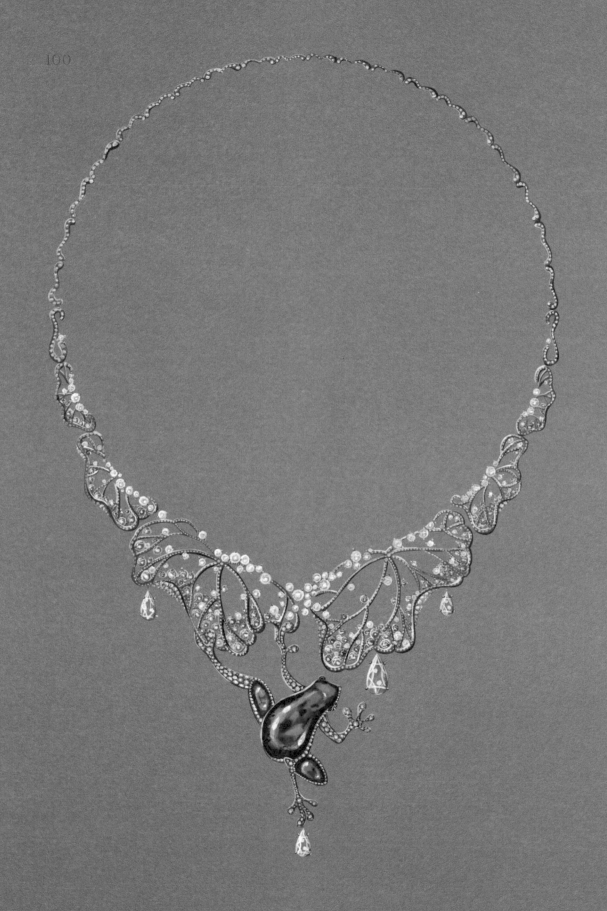

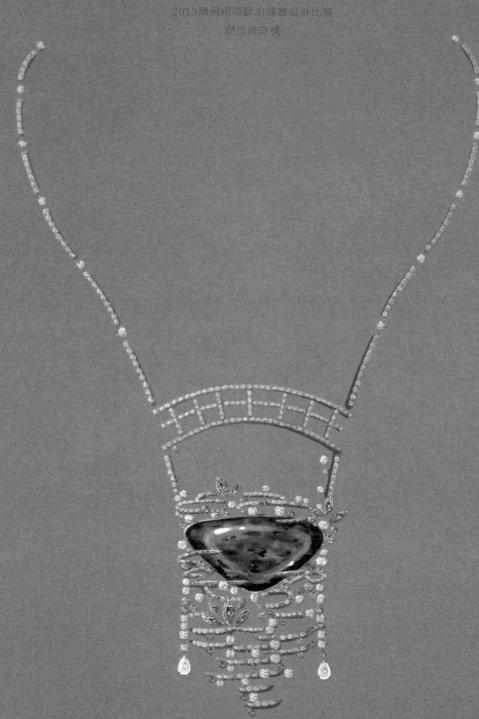

Lively Stars/侯冠禎
2015澳洲國際歐泊珠寶設計比賽
傑出設計獎

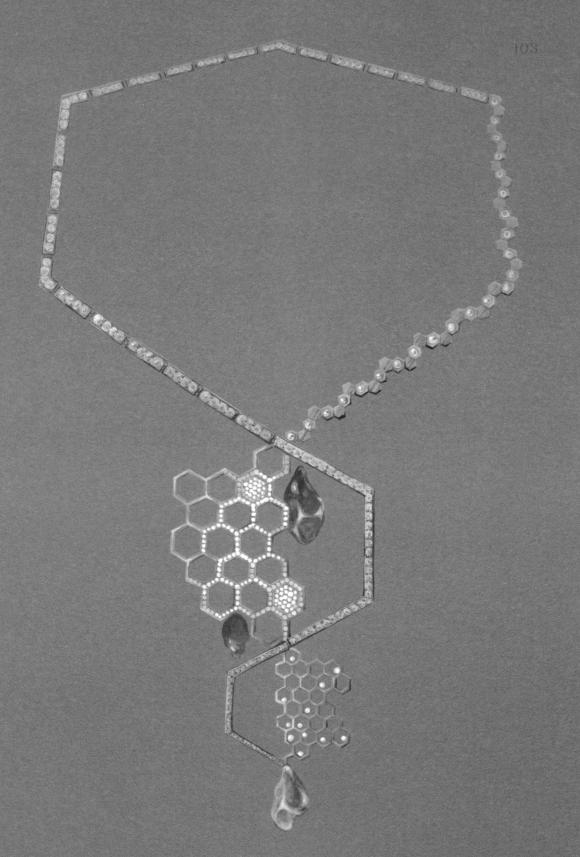

103

Purity/黃裕雯

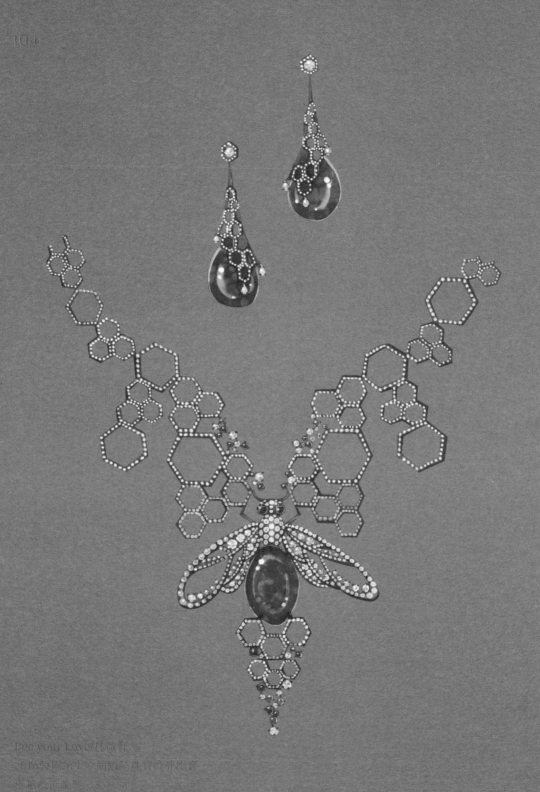

Bee your Love/林威軒
2016韓國第十六屆國際珠寶設計比賽
耳環及項鍊設計

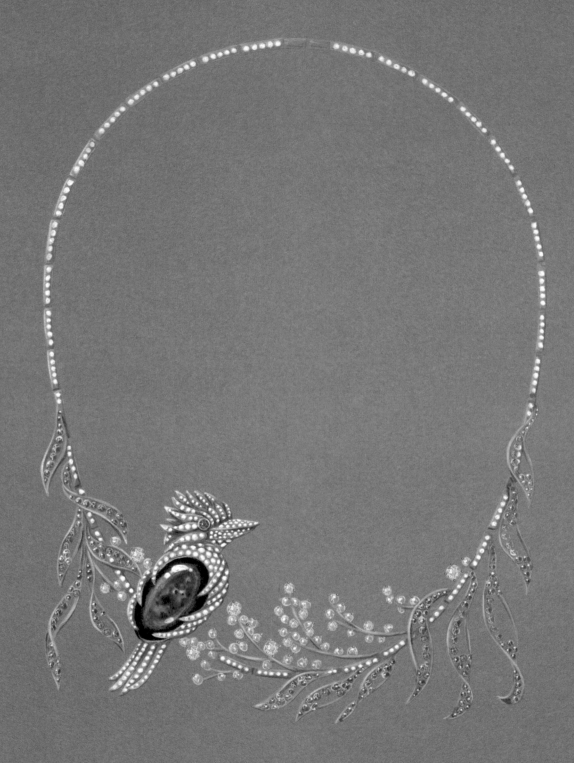

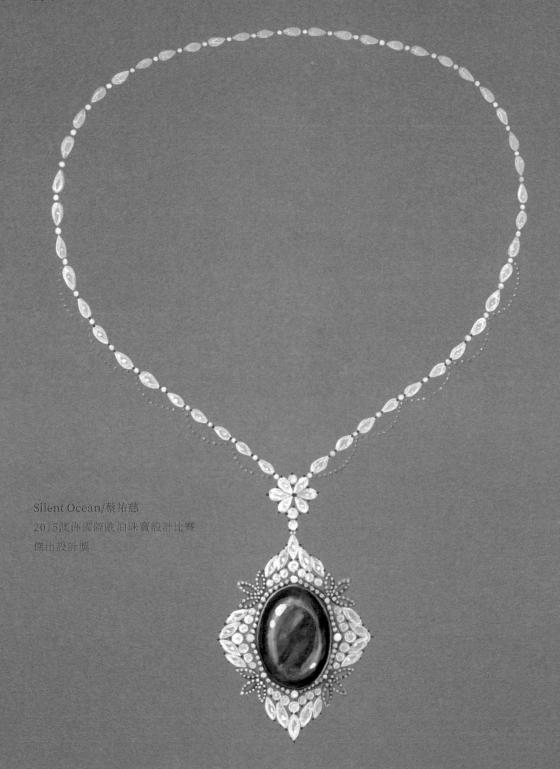

Silent Ocean/蔡祐慈
2015澳洲國際歐泊珠寶設計比賽
傑出設計獎

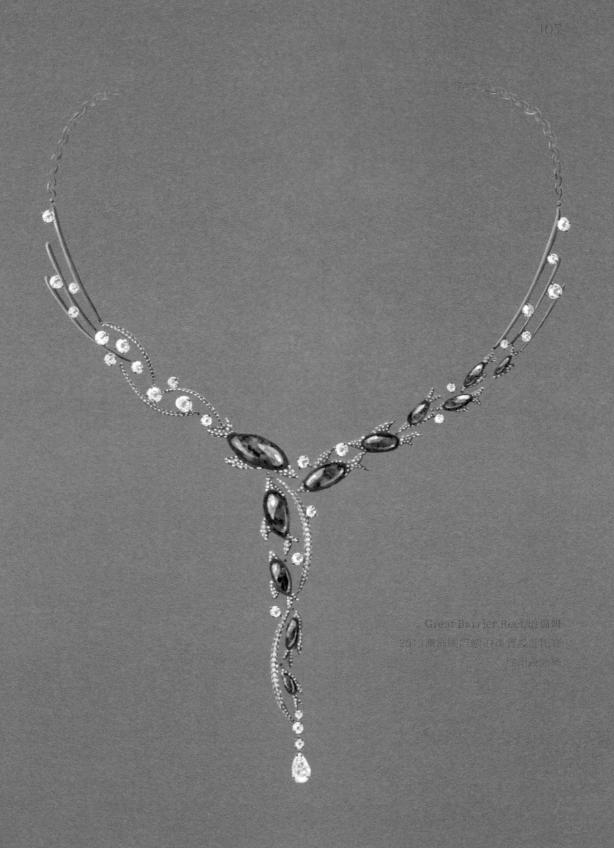

Great Barrier Reef/殷儷娟
2013澳洲國際銀白珠寶設計比賽
佳作獎得獎

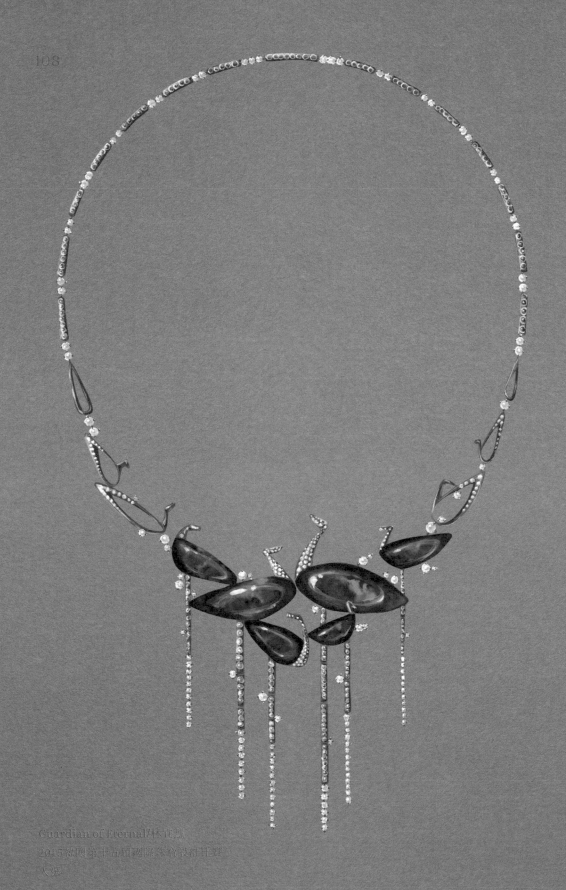

Guardian of Eternal/林宜穀
2015韓國第十五屆國際珠寶設計比賽
入選

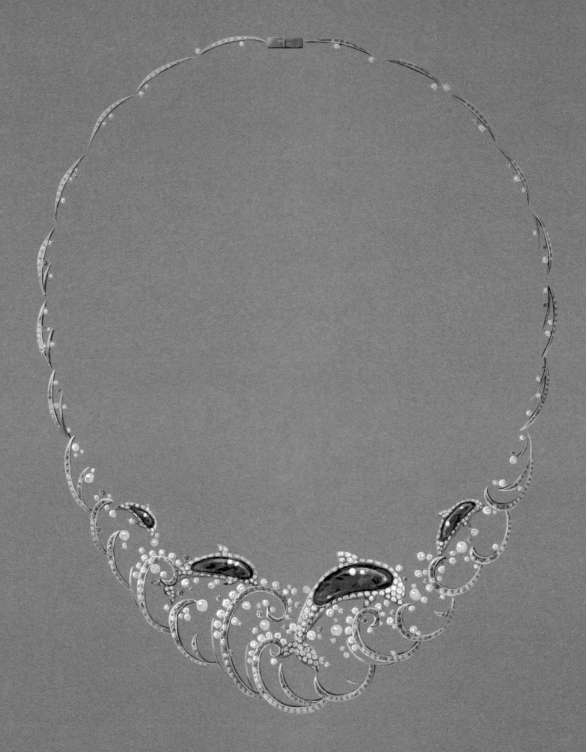

Together/盧佩吟

Snowy Night/張如卉
2017澳洲國際歐泊珠寶設計比賽
傑出設計獎

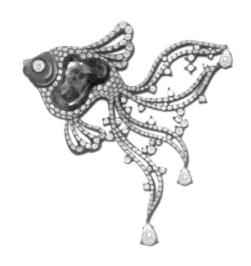

自由/郭賴秀珠
2014中國第四屆順德倫教珠寶首飾設計大賽
銀獎

「金魚體態婀娜多姿,色彩絢麗繽紛,
常見金黃橘紅色澤,宛若寶石火歐泊,
身後曳著如水絲花瓣般的尾鰭,曼妙
悠哉。紅鱗映照水波,周圍氣泡點點,
設計成活動的結構,添增配戴者靈動
輕窈,優雅高貴。」

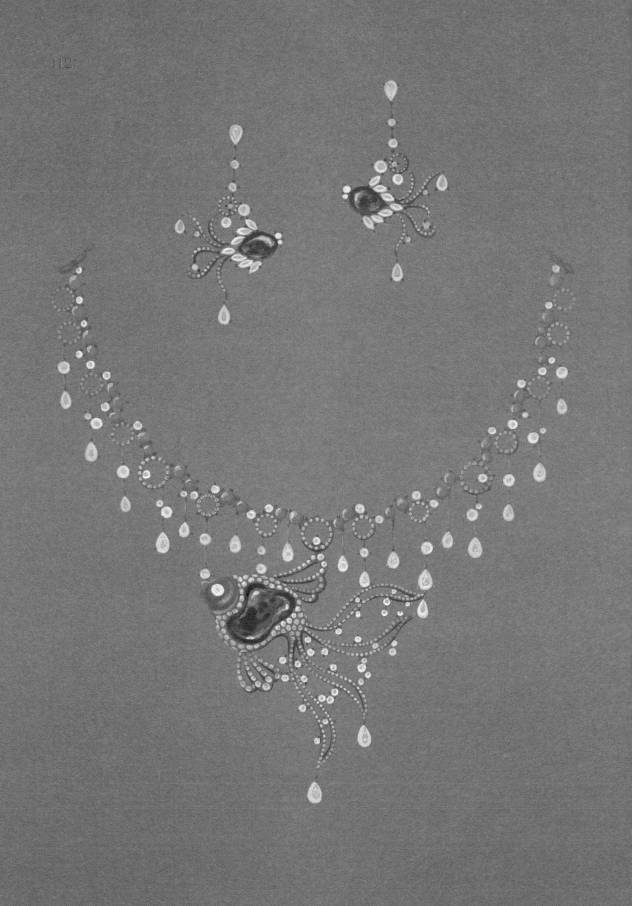

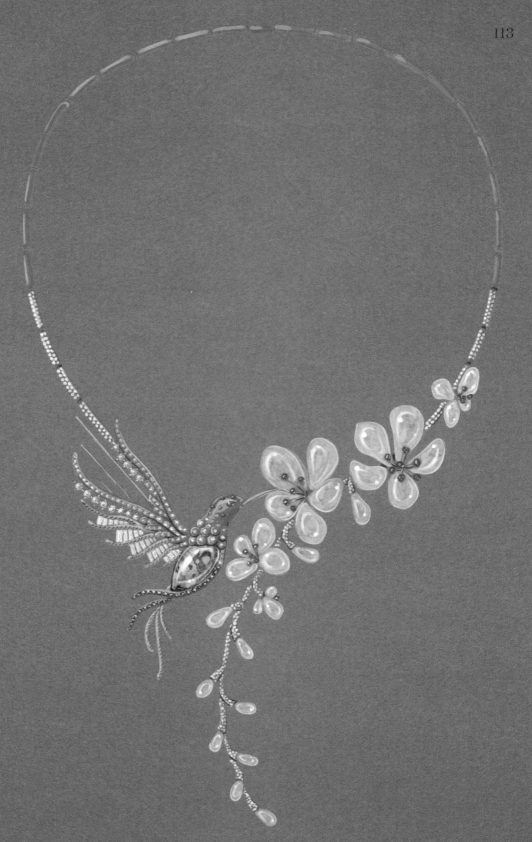

Wood-Nymph/呂宜姍

114

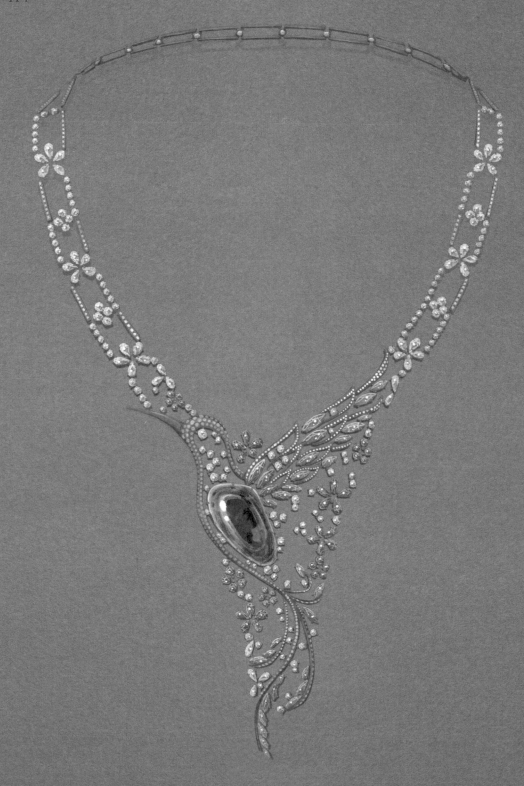

無限/林秉廉

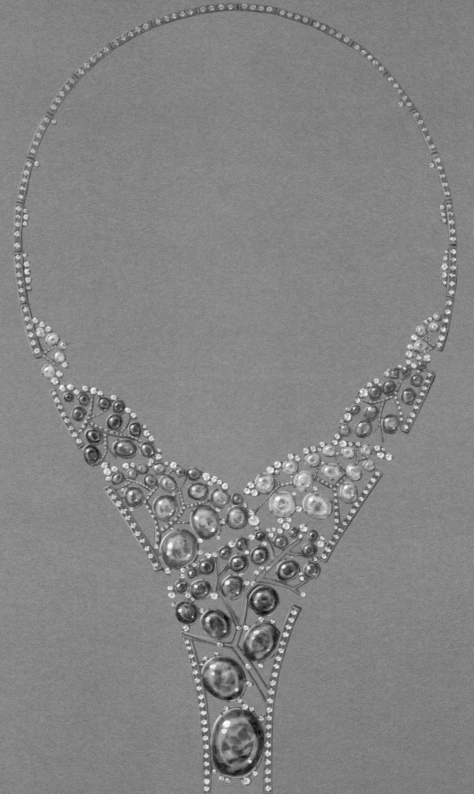

Dawn Blossoms/陳芳葵

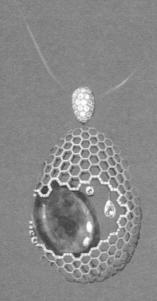

Waves/林聖芸

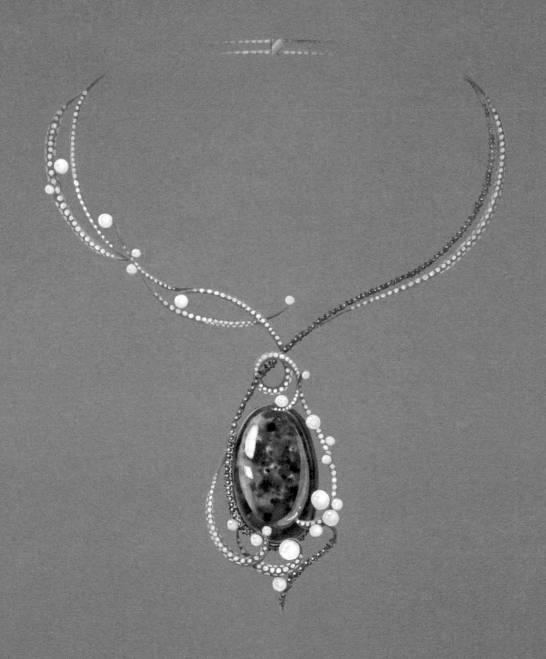

Return to the Blue Lagoon/黃以欣

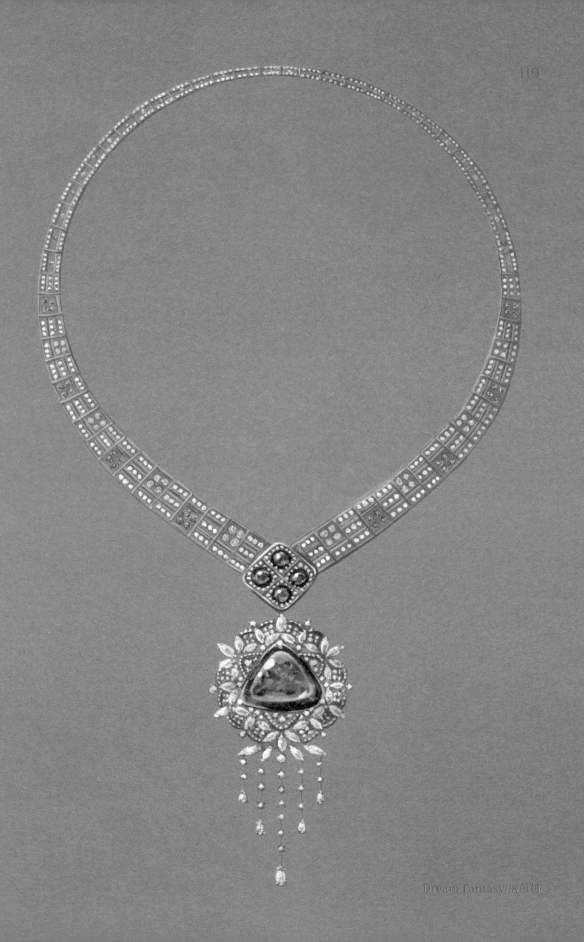

Dream Fantasy/瑶尉娜

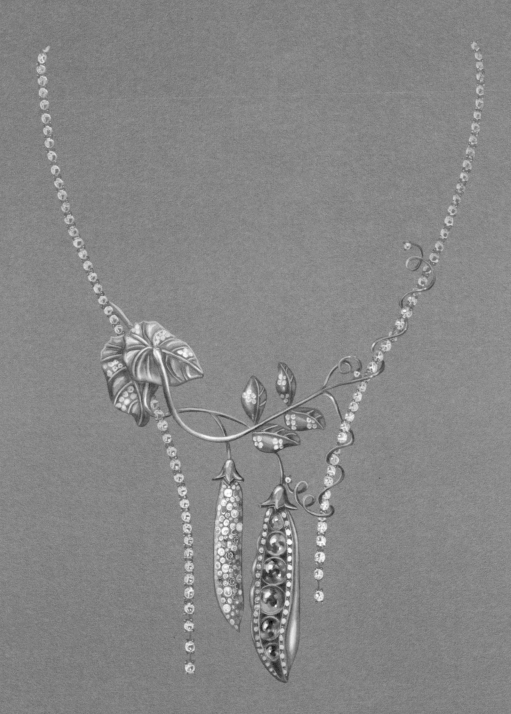

Wish/呂嘉芳

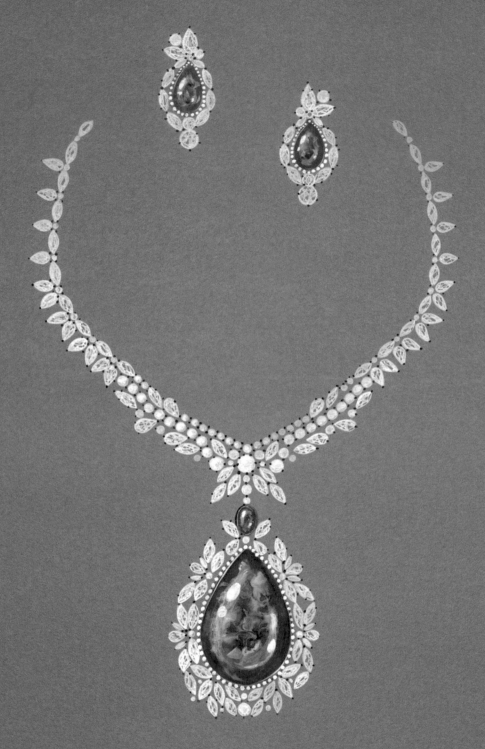

Embrace/曾宜秋

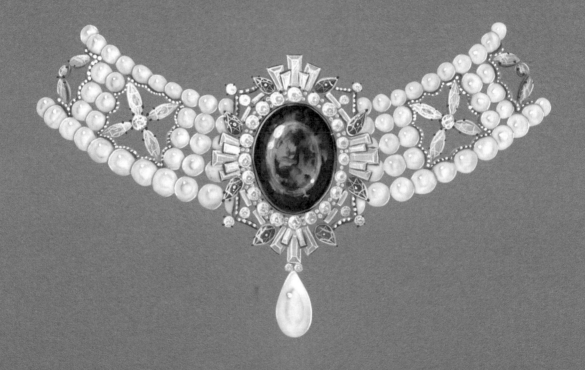

Peaceful Necta/黃淑儀

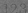

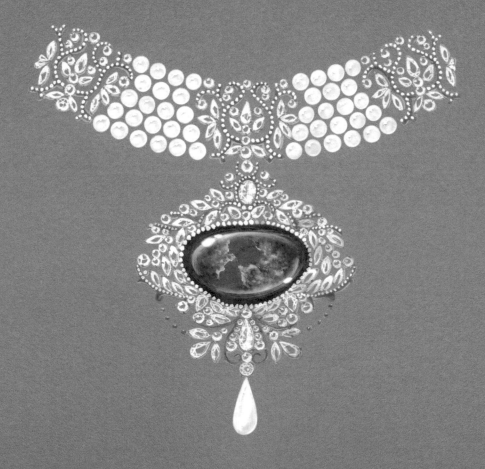

Party Queen/李鎮宏

124

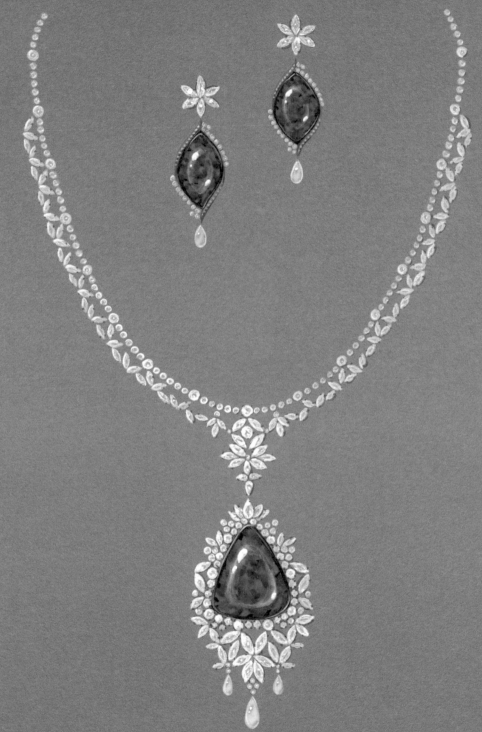

Ease/何嘉蕎

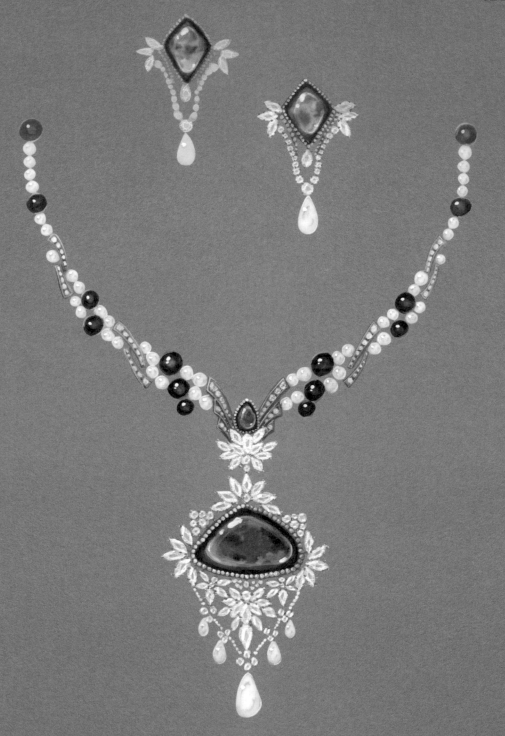

Sincere/張純萍

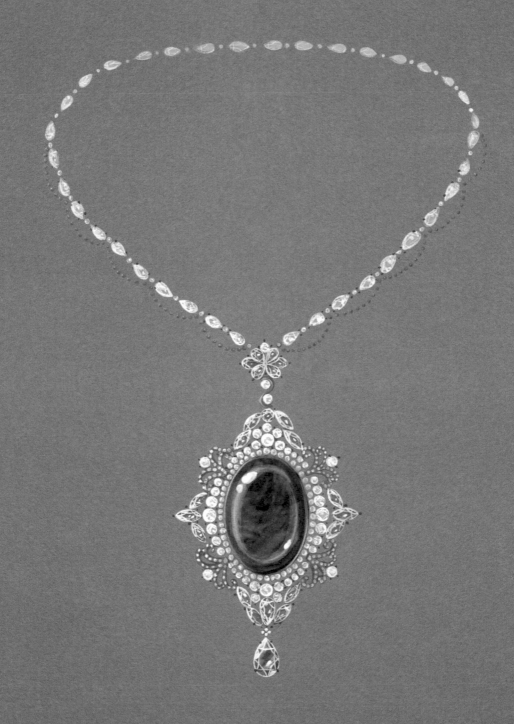

Mirror of the true/蔡祐慈

珊瑚 Coral

Forever Yours/李曉晴
2016印度JAS國際珠寶設計比賽
入圍獎

「荷花花語為堅貞、純潔、信仰、忠貞，它亦有許多的象徵意義，比如佳人或者表達『出淤泥而不染』的高尚情操。擷取荷花層疊的花瓣型態，搭配與荷花相稱艷而不俗的紅色珊瑚，一點一滴的將各種元素揉合轉化，把所有的美好都賦予在珠寶首飾之中。

設計『賦予』了每一件珠寶首飾的獨特，每一份獨特『創造』了珠寶設計的魅力。正是如此千變萬化的賦予和創造，充滿獨特魅力的展現，讓我鍾愛於珠寶設計。」

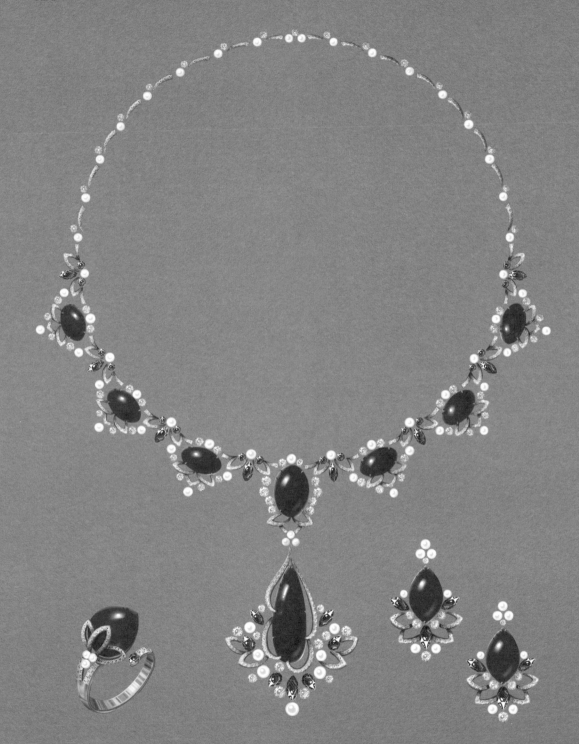

片翼蝶/鍾羽涵
2018台灣首屆昇恆昌珠寶設計大賞
優選獎

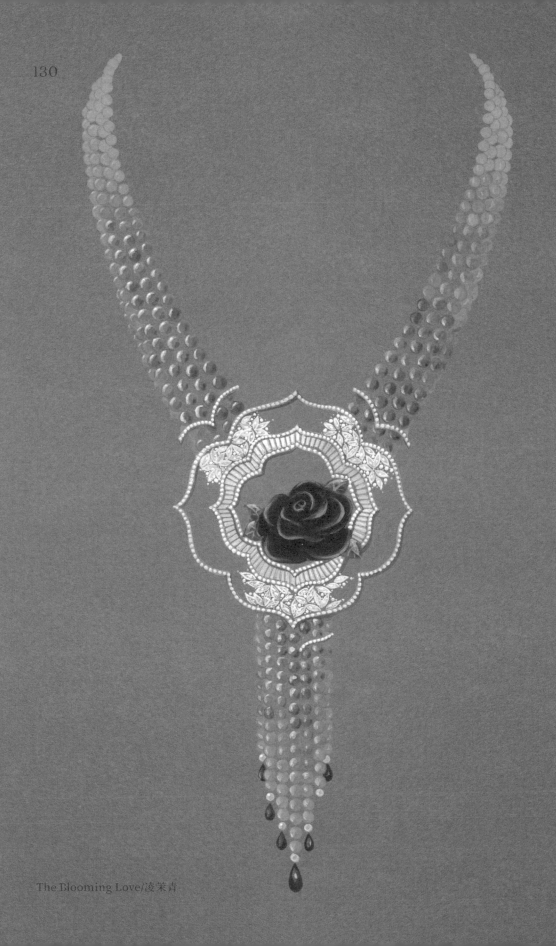

The Blooming Love/凌茉青

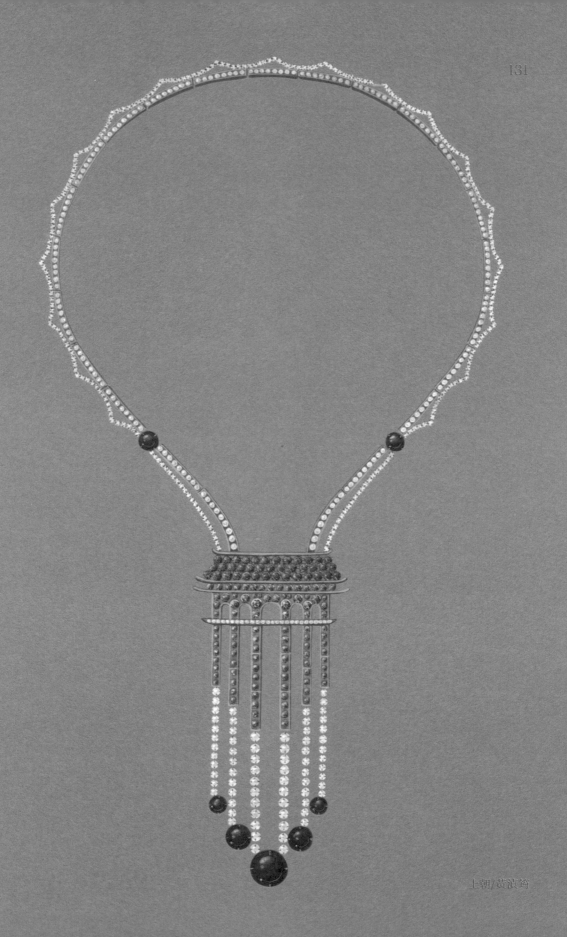

上朝/黄渍筠

Purity/吳佩容
2015韓國第十五屆國際珠寶設計比賽
入選

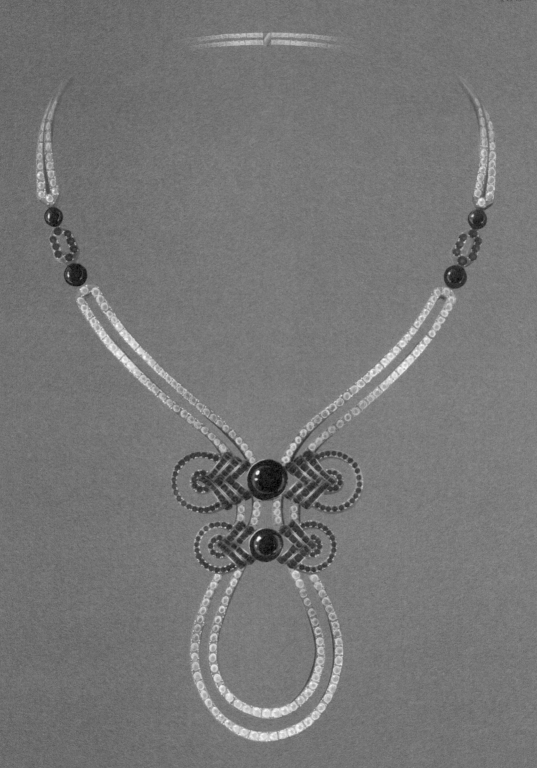

中國結/林玥彣

「中國結飾和中國紅都是中華民族文
化的經典元素，寓意吉祥祝福。藉紅
珊瑚的美色，中國結的形式融合設計
成項鍊，彰顯中華慶典的喜氣，傳遞出
更勝於言表的祈福心願。

繫紅線、結如意、環於頸、佩於深。珠
飾圓滿，結飾如意，中國結首飾讓編
織美的層次交會，更讓平安喜樂的蘊
意如影隨形。」

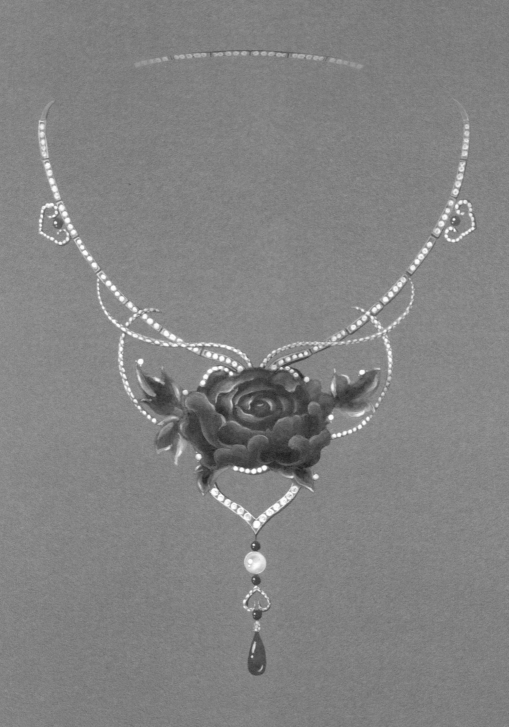

牡丹花開時/凌業青

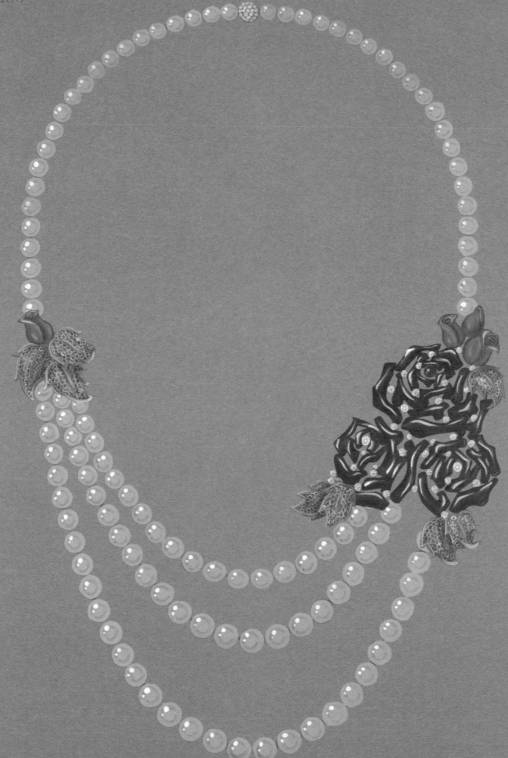

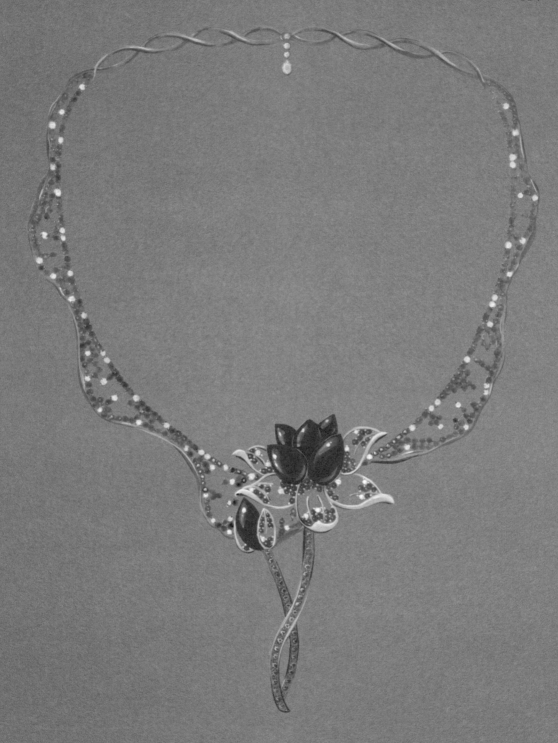

愛蓮說/楊怡靜

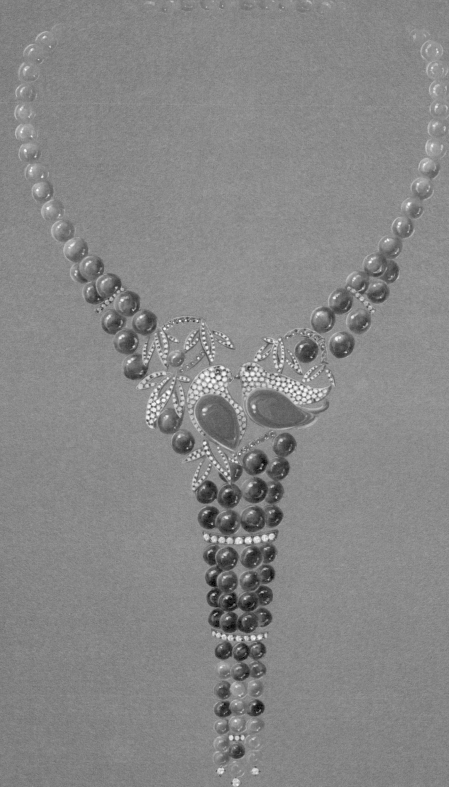

傾吻/陳芳葵

黃金 Gold

花開並蒂/屠蔚娜
2017香港JMA國際珠寶設計大賽
入圍獎

「珠寶設計師，是一位華麗的默劇表演家，每次的創作，宛如一場無聲的繽紛演出，在有限的舞台上演譯表現，將歷久彌新的材料結合，時而內斂、時而誇張，時而莊嚴又不失童心，展現出富有文化美學和典藏價值的裝飾藝術形式，賦予珠寶首飾不朽的精神靈魂！

從事平面、空間、產品設計近十年後巧遇珠寶的美好，內心渴望成為珠寶設計師，進而投入學習珠寶專業職能。短短的三個月，不僅快速建立珠寶設計邏輯、造形美學觀念以及珠寶材料、工法、結構、功能等專業知識。學成後，依照學院教授的設計系統就可獨立思考，發想創造出不同風格的設計作品。除了承接珠寶業者的委託設計，參加國際比賽更為自己開拓了寬廣的視野；贏得獎項肯定的同時，不但增加自信心和知名度，過程中，也獲得了寶貴的經歷和良師益友。」

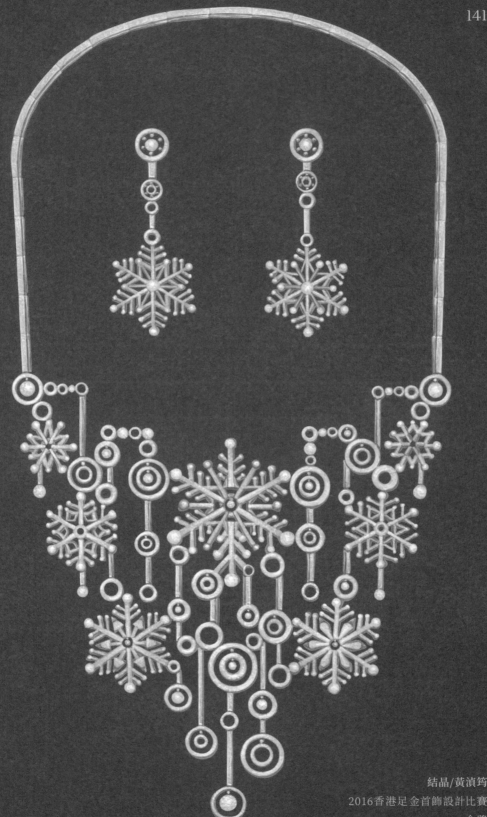

結晶/黃滇筠
2016香港足金首飾設計比賽
金獎

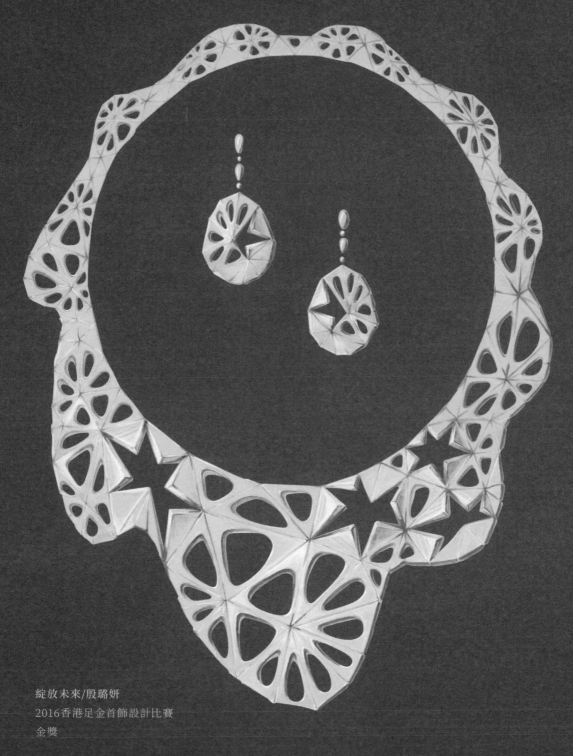

綻放未來/殷璐妍
2016香港足金首飾設計比賽
金獎

成品/頁200

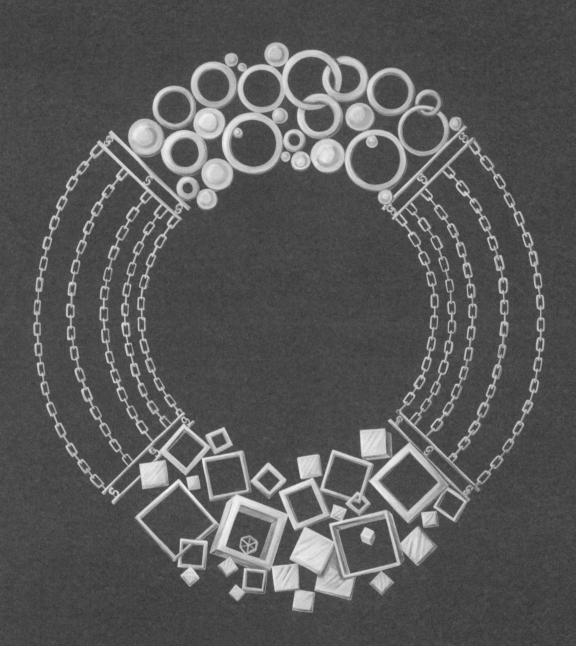

方圓/林聖芸

張詠甯/The kiss
2018香港足金首飾設計比賽
佳作獎

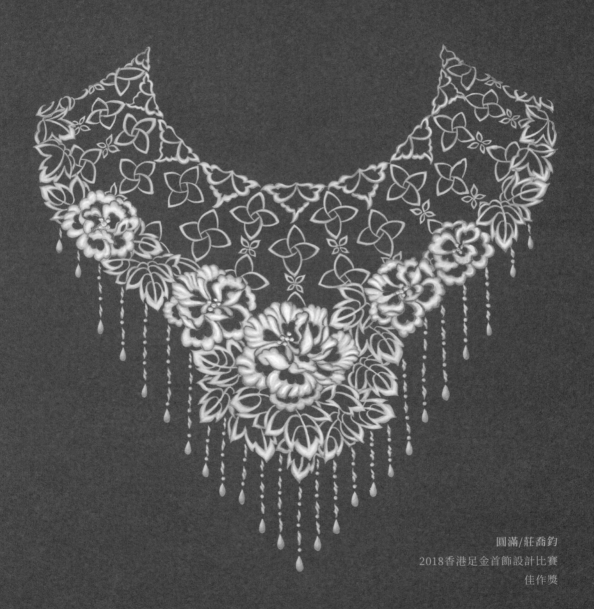

圓滿/莊喬鈞
2018香港足金首飾設計比賽
佳作獎

祝福花串/張愷芬
2018香港足金首飾設計比賽
金獎

成品/頁204

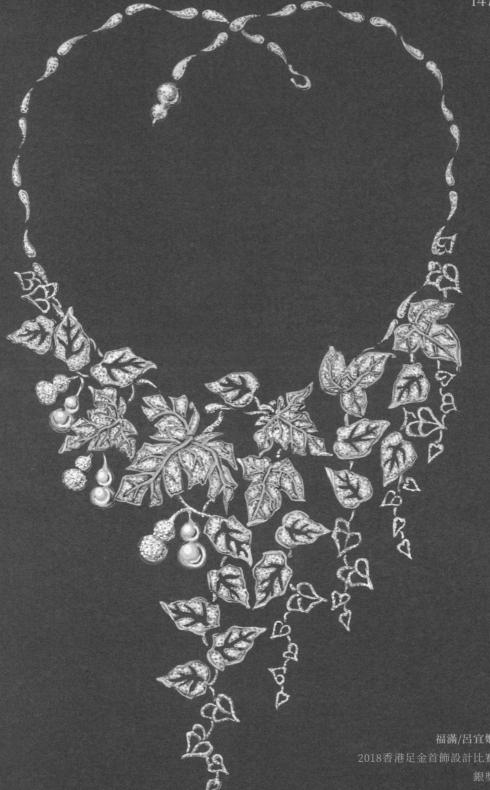

福滿/呂宜姍
2018香港足金首飾設計比賽
銀獎

成品/頁202

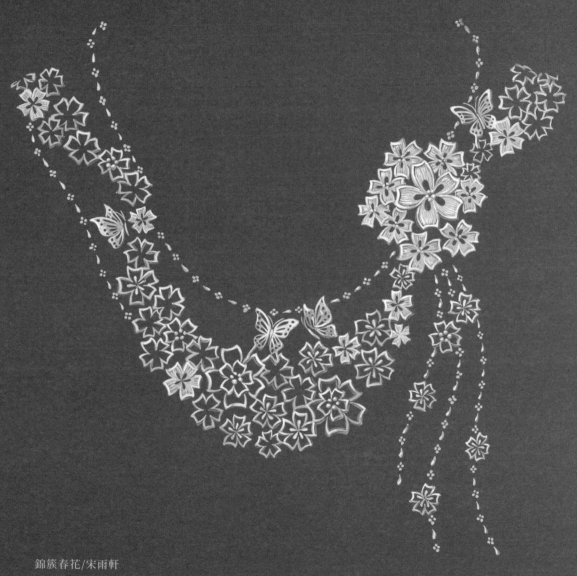

錦簇春花/宋雨軒
2018香港足金首飾設計比賽
佳作獎

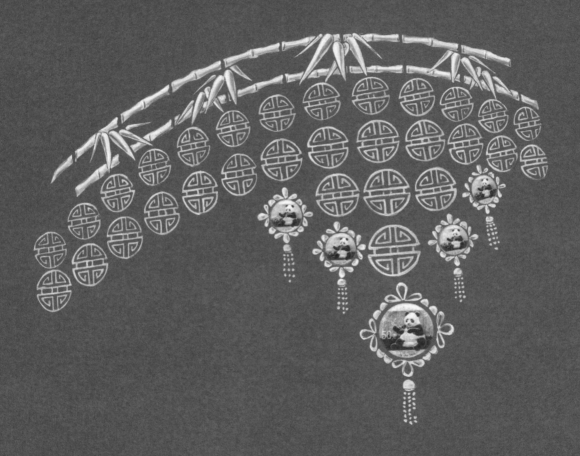

珠聯幣合/楊怡靜

祿/丁琬芳
2016香港足金首飾設計比賽
金獎

成品/頁206

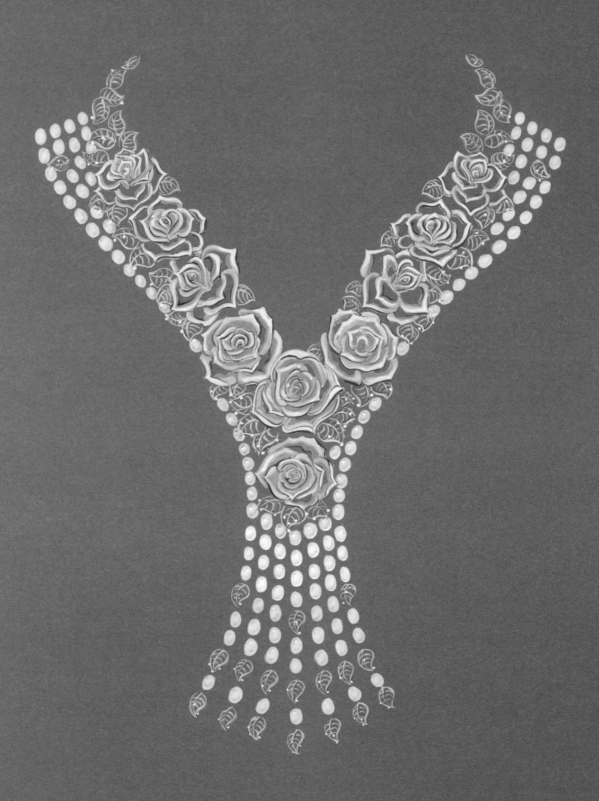

玫開眼笑/宋雨軒

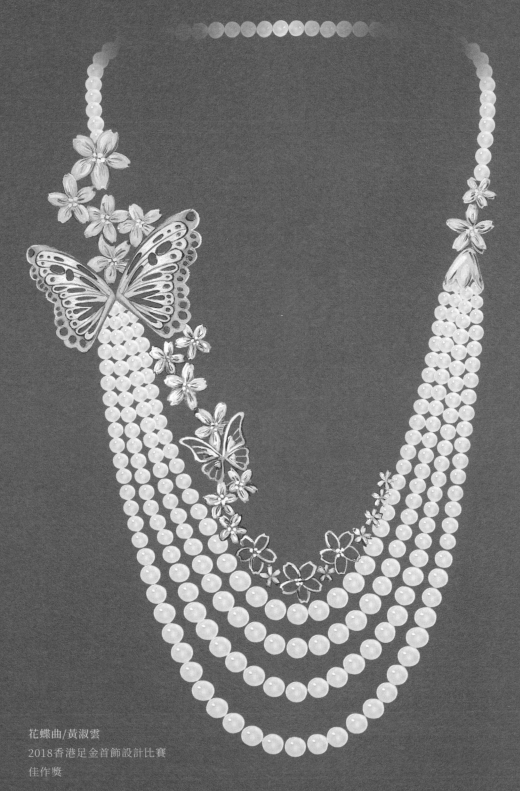

花蝶曲/黃淑雲
2018香港足金首飾設計比賽
佳作獎

彩帶幻想曲/陳盈盈

「課程學習的技術和理論只是打底,畢
業後的實務創作應用所面臨的種種困
難,才是真正的挑戰。珠寶設計師的培
訓養成,一要名師指導,二要自身努力
不懈,唯有不斷地燃燒熱情,才能夠突
破重重關卡。身為臺灣珠寶藝術學院
第一屆的學員,有幸參與其十年的發
展,親眼見證歷屆學弟妹心血付出與
豐碩成果,與有榮焉。」

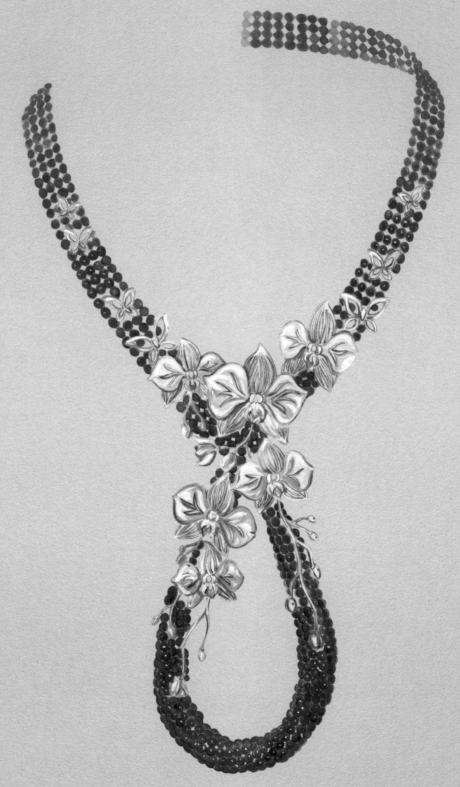

蝶戀蘭/吳佩容

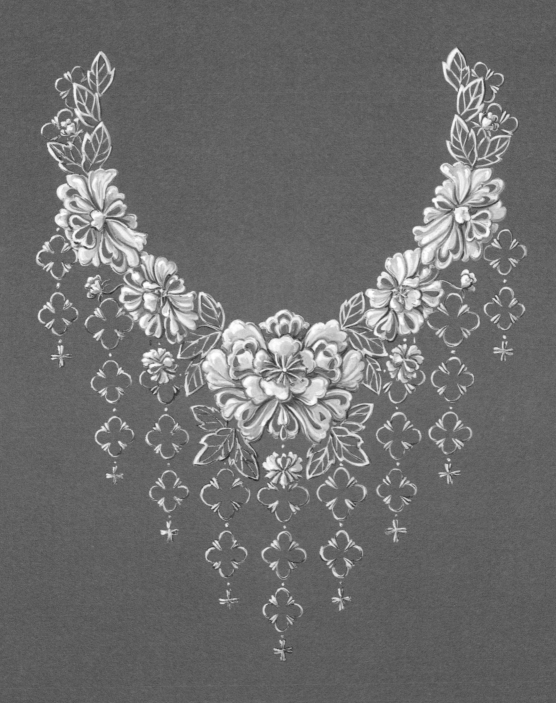

牡丹芳/李雨青

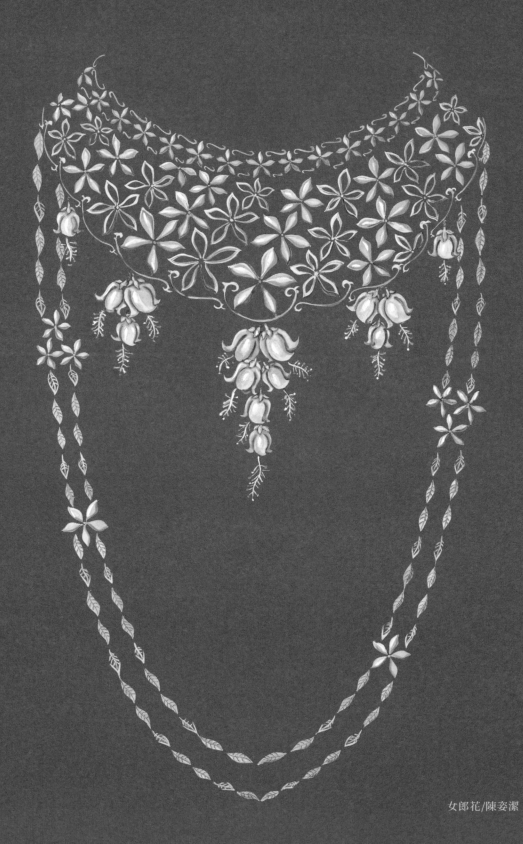

女郎花/陳姿潔

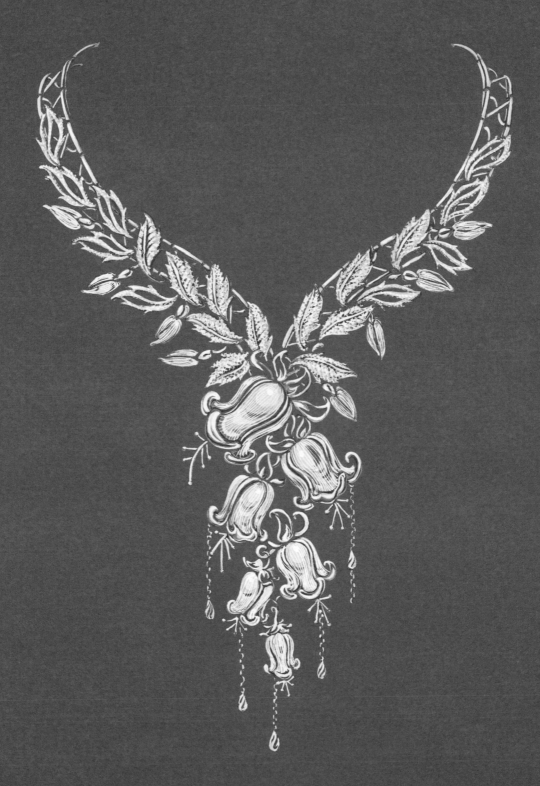

幸福的終點/呂宜姍

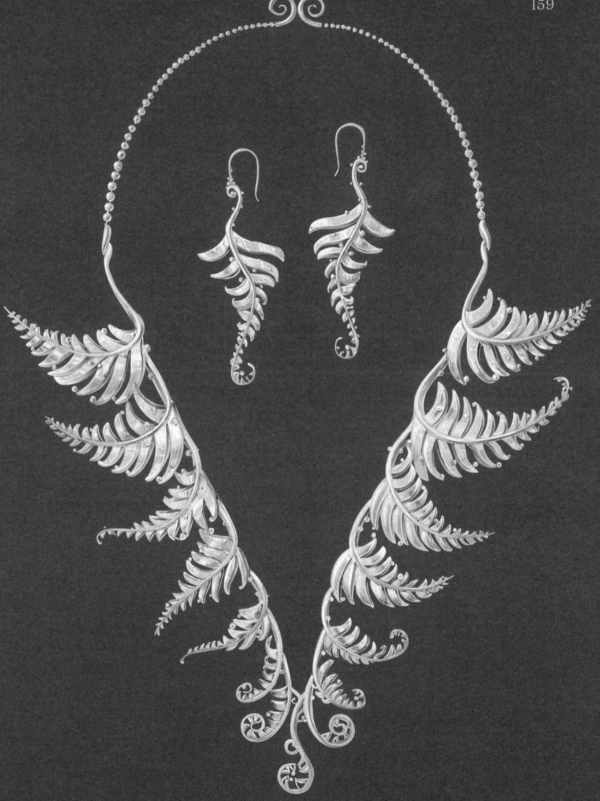

蕨/陳馨月

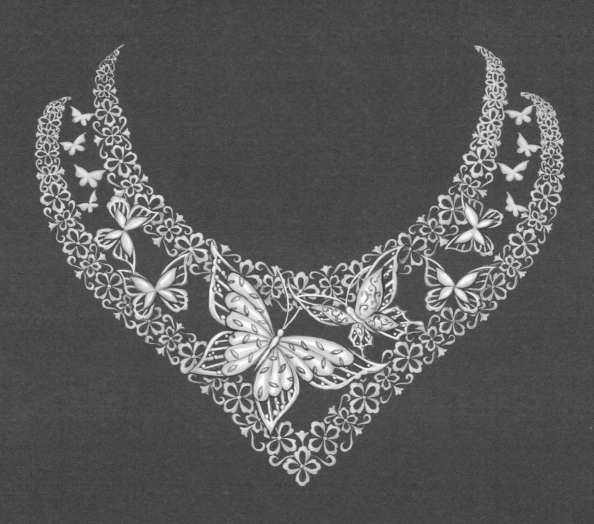

雙宿雙飛/李芷彤

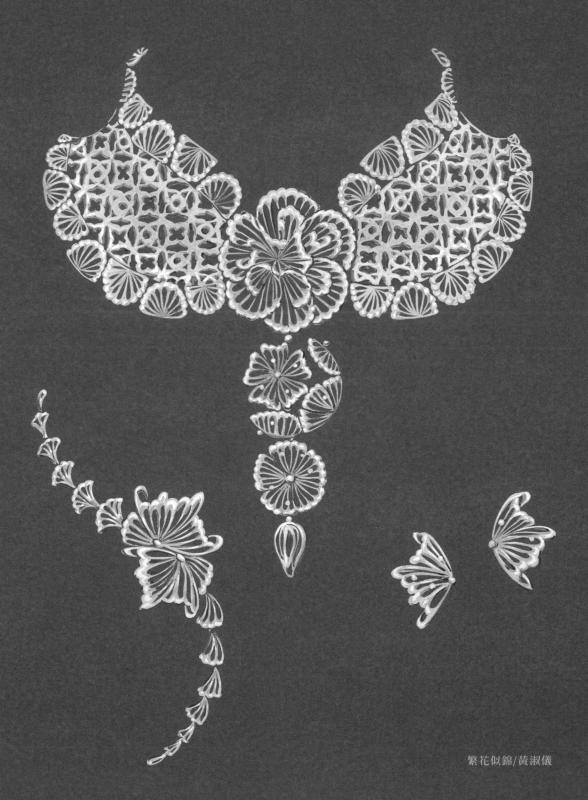

繁花似錦/黃淑儀

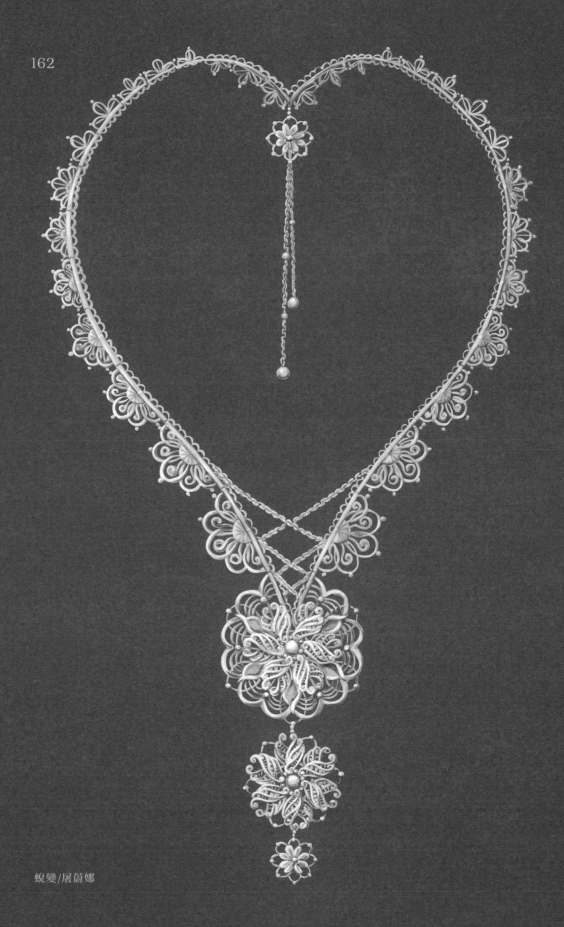

蛻變/屠蔚娜

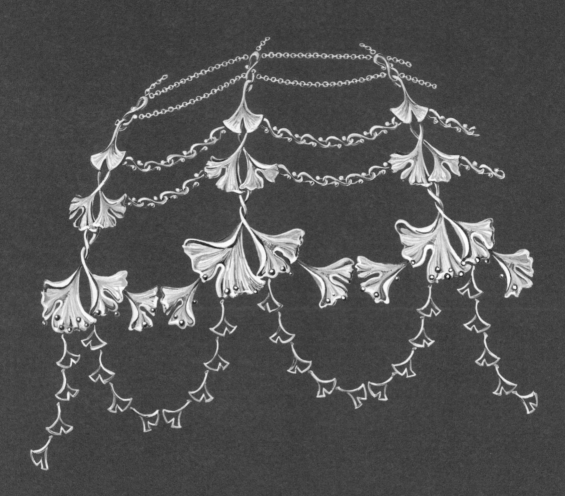

杏福微雨/吳祝銀

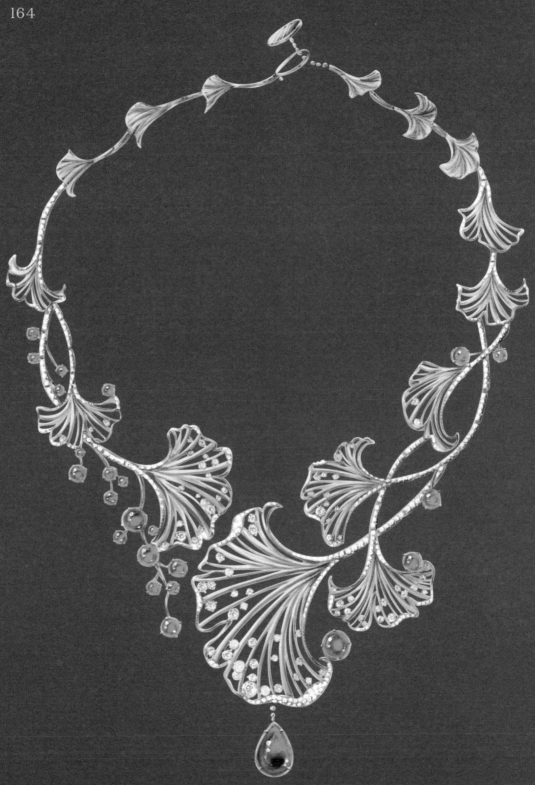

黃金歲月/李曉晴

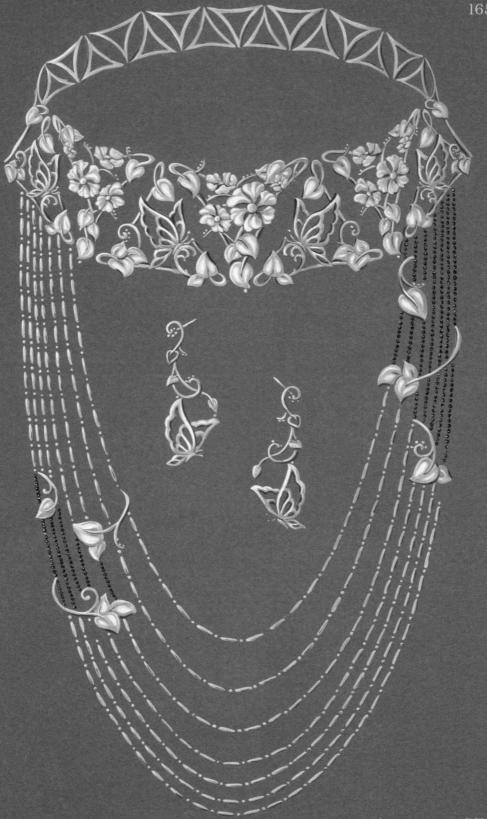

Modern Romance/盧佩吟

金色浪潮/陳芳葵

C

人才為企業之本，一個沒有人才的行業，難有未來。而教育則是培育人才最直接且有效的方式。

珠寶行業綜跨了「工藝產業、設計品牌時尚產業、產品設計產業」，其經濟規模龐大，引帶寬廣的就業機會。臺灣現行的教育體制，並無設置珠寶專業職能系所，新生代不得其門而入，知識和技術的傳承缺口，導致接續人才短缺。

全球化拓寬了消費者的視野，數位時代改變了消費者的行為模式，消費者參與度和期望值亦隨之變動。有鑑於此，臺灣珠寶藝術學院積極整合「產、官、學、勞、研」跨領域優勢，應用組織綜效發展；對外，主動爭取國際珠寶事務的參與；對內，則呼籲各界重視珠寶產業所創造的經濟效益，及珠寶職能引帶的就業機會，促進更多有利於珠寶產業振興發展之政策制訂。

我們期許透過珠寶技職教育的力量，為產業「育才、引才、留才」，相信唯有新活力投入珠寶業，才能帶動臺灣珠寶產業轉型升級，成功迎向數位經濟時代的新挑戰。

我們的理念：

1－辦理珠寶之「技術、學術、藝術」推廣教育及展演活動。

2－從事珠寶專業、設計知識、工藝技術、管理經營之人才育成。

3－贊助或獎勵支持珠寶專業升級之創新與研發事務。

4－發展珠寶專業智能之「系統、著作、出版、發表」。

5－提倡有利於臺灣珠寶產業發展的政策法規制定。

6－設立珠寶職能教育平台，共享「人脈、資訊、資源」。

7－爭取國際珠寶事務活動參與，提高臺灣國際能見度。

8－倡導珠寶之正向價值，增進民眾喜愛認同珠寶首飾。

9－孕育臺灣珠寶設計師品牌。

10–創新大中華珠寶藝術形式。

The jewellery trade spans the Handicrafts, Designer Fashion, and Product Design industries. The trade has a huge economic scale, and provides a wide range of employment opportunities. In Taiwan's current educational system there are no faculties providing professional education in jewellery. Thus, the new generation has no means by which to enter the profession, and there is a gap in the passing down of knowledge and skills, which will surely lead to a shortage of talented successors. Talent is the foundation of enterprise. An industry without talented professionals is an industry without a future! Education is the most direct and effective way to cultivate talented professionals.

Globalization has broadened the field of vision of consumers. The digital era has changed the patterns of consumer behaviour, and the degree of participation and expectations has in turn also changed. In view of this, the Jewellery Arts Institute of Taiwan actively integrates multidisciplinary advantages from industry, government, academia, labour, and research, and applies organizational synergy to its development.

In the international arena, we dynamically strive for participation in international jewellery affairs. Domestically, we appeal to people from various walks of life and spheres of endeavour to value the economic benefits created by the jewellery industry, as well as the employment opportunities provided through the role of jewellery. We also promote the formulation of more policies that are conducive to the revitalization of the jewellery industry.

The Jewellery Arts Institute of Taiwan hopes to utilize the power of vocational education to build a pool of diverse competitive strength for the Taiwan jewellery industry, and to 'nurture talent, recommend talent, and retain talent' for the jewellery industry. We believe that with this new vitality for the jewellery industry to participate, we can expect to lead the transformation and upgrading of the jewellery industry in Taiwan, successfully meeting the new challenges of the digital economy.

art@jart.org.tw
+886 2 2752-0856

2020

— 比利時HRD國際鑽石首飾設計大賽
　　耳環類冠軍、季軍；戒指類亞軍、入圍獎七項

— 法國第二屆Bijorhca珠寶設計比賽
　　十強晉級三強獎項

— 韓國第二十屆國際珠寶設計比賽
　　銅獎、卓越設計師獎、特選獎二項、
　　榮譽獎八項

— 香港足金首飾設計比賽
　　金獎三項、佳作獎
　　香港周大福珠寶集團贊助製造

— 中國首屆華彩國際彩色寶石設計大賽
　　銅獎

— 中國山下湖珍珠首飾創意設計大賽
　　優秀獎二項
　　阮仕珍珠贊助製造

— 台灣決戰蝦皮伸展台設計大賽
　　飾品配件組佳作獎
　　Kelra Accessories贊助製造

— 中國第三屆招金杯黃金珠寶設計大賽
　　優秀獎

— MIC創意大師國際珠寶首飾設計大賽
　　佳作獎

— 中國月印萬川-珠寶首飾設計作品徵集
　　佳作獎、入圍獎三項

2019

— 法國第二屆3design珠寶設計大賽
　前十強、最佳設計獎、佳作獎

— 韓國第十九屆國際珠寶設計比賽
　特選獎九項、榮譽獎二十一項

— 台灣第二屆昇恆昌珠寶設計大賞
　市場潛力獎、傑出獎、優選獎、入圍獎四項

— 香港JNA國際珠寶設計大賽
　優異獎、最佳市場價值獎
　香港大溪地黑珍珠協會贊助
　香港民生珠寶有限公司製造

— 澳洲國際歐泊珠寶設計比賽
　傑出設計獎

— 中國TTF鼠年生肖首飾設計大賽
　佳作獎

— 香港翡翠創作雙年賽2018/19
　佳作獎、入圍獎六項

— 中國第二屆寶慶杯珠寶首飾設計大賽
　入圍獎三項

— 深圳第六屆國際珠寶首飾設計大賽
　優秀獎

— 中國金伯利鑽石50克拉全球設計甄選
　入圍獎

— 上海新銳首飾設計大賽
　入圍獎二項

— 中國KDC國際鑽石首飾設計大賽
　入圍獎

2018

— 香港JMA國際珠寶設計比賽
　冠軍、優異獎、入圍獎二項

— 香港足金首飾設計比賽
　金獎三項、銀獎、銅獎、佳作獎七項
　香港周大福珠寶集團贊助製造
　首獎受香港貿易發展局邀請提名
　「冠軍中的冠軍」

— 台灣首屆昇恆昌珠寶設計大賞
　金獎、銀獎、優選獎三項、佳作獎三項、
　網路人氣獎、特別獎

— 韓國第十八屆國際珠寶設計比賽
　特選獎四項、榮譽獎十項

— 中國TTF豬年生肖首飾設計大賽
　前十強二項、佳作獎

— 中國翡翠神工獎
　翡翠首飾設計組：銅獎、入圍獎

— 中國第二屆上塘銀飾小鎮珠寶設計大賽
　銅獎

— 中國山下湖珍珠首飾創意設計大賽
　優秀獎
　阮仕珍珠贊助製造

— 中國中和盛世珠寶設計大賽
　三等獎、最佳工藝獎
　獲主辦單位贊助製造

— 新加坡珠寶設計比賽
　佳作獎

— 中國第二屆招金杯黃金珠寶設計大賽
　優秀獎七項

— 中國珠寶首飾設計與製作大賽
　最佳造型獎

2017

— 韓國第十七屆國際珠寶設計比賽
　會長獎二項、卓越設計師獎二項、
　特選二項、榮譽獎四項

— 新加坡珠寶設計比賽
　冠軍、亞軍、佳作獎二項

— 台灣國際創意珠寶設計大賽
　金獎

— 中國TTF狗年生肖首飾設計大賽
　前十強、佳作獎

— 中國TTF克拉鑽戒國際珠寶首飾設計大賽
　佳作獎
　ttf大凡珠寶首飾有限公司贊助製造

— 國際時尚翡翠首飾設計大賽
　公開繪圖組第三大獎

— 香港JMA國際珠寶設計比賽
　優異獎、入圍獎

— 美國國際珍珠首飾設計比賽
　最佳視覺大獎

— 澳洲國際歐泊珠寶設計比賽
　傑出設計獎二項

— 台灣大東山點石成金設計公開賽
　佳作獎

2016

— 美國國際珍珠首飾設計比賽
　總冠軍、最佳設計師獎、最佳視覺獎
　香港周大福珠寶集團贊助製造
　發表於2017美國AGTA、JCK珠寶展會

— 新加坡珠寶設計獎比賽
　冠軍、季軍、佳作獎八項

— 中國TTF克拉鑽戒國際珠寶首飾設計大賽
　銀獎
　ttf大凡珠寶首飾有限公司贊助製造

— 香港足金首飾設計比賽
　金獎三項、佳作獎八項
　香港周大福珠寶集團贊助製造
　首獎受HKTDC邀請參加「冠軍中的冠軍」

— 中國首屆國際珍珠首飾設計大賽
　二等獎、三等獎、優秀獎五項、佳作獎十三項
　千足珍珠、海天生珍珠贊助製造

— 中國首屆順德珠寶首飾創意設計大賽
　設計銀鷹獎、佳作獎四項

— 中國首屆玉瑤獎首飾設計大賽
　婚慶裝二等獎、晚宴裝三等獎、職場裝三等獎
　新秀獎四項、佳作獎三項、入圍獎八項

— 中國TTF雞年生肖首飾設計大賽
　佳作獎

— 泰國GIT國際珠寶設計比賽
　第三名、佳作獎

— 韓國第十六屆國際珠寶設計比賽
　卓越設計師獎三項、特選獎四項、榮譽獎四項

— 印度JAS國際珠寶設計比賽
　入圍獎三項

— 香港JMA國際珠寶設計比賽
　佳作獎五項

2015

— 美國國際珍珠首飾設計比賽
　珍珠光澤獎、傑出設計獎、珍珠光彩獎、
　婚禮珍珠獎
　台灣良和時尚珠寶贊助製作
　發表於2016美國AGTA、JCK珠寶展會

— 澳洲國際歐泊珠寶設計比賽
　總冠軍、傑出設計獎十項

— 上海國際首飾設計大賽
　學生組佳作獎、職業組佳作獎三項

— 韓國第十五屆國際珠寶設計比賽
　卓越設計師獎二項、特選獎四項

— 杜拜DIJW國際珠寶設計大賽
　阿拉伯風格設計佳作獎、3D電腦繪圖佳作獎
　創新風格設計佳作獎二項

— 中國珠寶首飾設計與製作大賽
　最佳創新設計獎、優秀獎二項

— 中國第二屆印象孔雀珠寶設計大賽
　最佳繪圖獎二項、網路人氣獎三項

— 香港JMA國際珠寶設計比賽
　佳作獎

— 中國第四屆國際珠寶首飾設計大賽
　專業組優秀獎

2014

— 上海國際首飾設計大賽
　三等獎、最佳工藝製作獎
　結締珠寶製造

— 中國第四屆順德倫教珠寶首飾設計大賽
　銀獎

— 中國金鑲玉創意設計大賽
　最佳創意獎

— 香港足金首飾設計比賽
　佳作獎

— 美國國際珍珠首飾設計比賽
　傑出設計獎

— 中國首屆印象孔雀珠寶設計大賽
　優秀獎

— 中國第四屆國際珠寶首飾設計大賽
　專業組優秀獎

2013

— 澳洲國際歐泊珠寶設計比賽
　總冠軍、傑出設計獎九項

— 杜拜DIJW國際珠寶設計大賽
　創新設計類組總冠軍

— 美國國際珍珠首飾設計比賽
　珍珠光彩金獎、優異設計獎二項

— 中國第三屆國際珠寶首飾設計大賽
　專業組優秀獎；學生組二等獎二項、
　三等獎、優秀獎
　丰沛珠寶贊助製造

— 香港第九屆國際南洋珠首飾設計大賽
　公開組耳環類銀獎、衫針類銀獎、
　優選獎三項；學生組冠軍、亞軍、殿軍
　維多利亞珠寶贊助製造

— 馬來西亞MIJF國際珠寶設計大獎
　項鍊類組首獎、胸針類組佳作獎
　文化部獎勵補助

2012

— 香港IU國際寶石首飾設計大賽
　優異設計大獎、佳作獎三項
　文化部獎勵補助
　台灣良和時尚珠寶贊助製作

— 馬來西亞MIJF國際珠寶設計大獎
　手鍊類組首獎、胸針類組首獎
　文化部獎勵補助

— 中國時尚–CCTV彩寶首飾設計大賽
　優秀獎三項

— 美國國際珍珠首飾設計比賽
　優異設計獎

— 台灣紅色魅力寶石珊瑚創意設計比賽
　第二名

2011

— 澳洲國際歐泊珠寶設計比賽
　傑出設計獎五項、佳作獎二項

— 台灣寶石協會珠寶設計比賽
　浪漫婚禮優異獎

2020

— HRD Design Awards – Winner and 2nd Runner Up of diamond earrings category, 1st Runner Up of diamond ring category and seven Nomination Awards.

— 2nd Bijorhca Jewellery Awards – Three Nomination Awards in total top ten selected.

— Korea 20th International Jewelry Design Contest – Bronze Award, Designer's Excellence Award, two Special Selection Awards and eight Honorable Mention Awards.

— Chuk Kam Jewellery Design Competition – Three Winners and Finalist. Awarded pieces are sponsored by Chow Tai Fook Jewellery Group, Katex Jewellery Ltd, Leo Foo Group for manufacturing.

— The 1st Hua Cai International Grand Prix for Colored Stone Design – Bronze Award.

— ShanXiaHu Creative Pearl Jewelry Design Award – Two Excellence Awards. Awarded pieces are sponsored by Ruan's Pearl for manufacturing.

— Shopee Fashion Runway – Finalist of Jewelry Accessories category.

— The 3rd Zhao Jin Cup Gold Jewelry Design Award – Excellence Award.

— Masters In Creativity International Jewellery Design Contest – Finalist.

— Yue Yin Wan Chuan Jewelry Design Selection – Finalist and three Nomination Awards.

2019

— 3design 3D Jewelry Design Contest – Top Tenth Prize, Best Design Award and Finalist.

— Korea 19th International Jewelry Design Contest – Nine Special Selection Awards and twenty-one Honorable Mention Awards.

— Ever Rich Jewelry Design Award – Popular Award, Brilliant Award, Merit Award and four Nomination Awards.

— JNA Jewellery Design Competition – Merit Award and Commercial Award. Awarded piece is sponsored by Tahitian Pearl Association H.K. and manufactured by Man Sang Jewellery Ltd.

— International Opal Jewellery Design Awards – High Commendation Award.

— TTF: Year of the Mouse Jewellery Design Contest – Finalist.

— H.K. Fei Cui Design Biennial Contest 2018/19 – Finalist and Six Nomination Awards.

— The 2nd Pao Ching Cup Jewelry Design Competition - Three Nomination Awards.

— The 6th Shenzhen International Jewelry Design Competition - Excellence Award.

— Kimberlite Diamond 50-Carat Global Design Competition - Nomination Award.

— Shanghai New Talent Design Competition – Two Nomination Awards.

— International Diamond Jewelry Design Competition - Nomination Award.

2018

— JMA International Jewellery Design Competition –Winner, Commended Award and two Nomination Awards.

— Chuk Kam Jewellery Design Competition – Three winners, 2nd Prize Award, 3rd Prize Award and seven Finalists. Awarded pieces are sponsored by Chow Tai Fook Jewellery Group, Katex Jewellery Ltd, Leo Foo Group for manufacturing. Winners are nominated for H.K. Trade Development Council's Champion of the Champions Award.

— The 1st Ever Rich Jewelry Design Award – Gold Award, Silver Award, three Merit Awards, three Honorable Mention Awards, Peoples Choice Award and Special award.

— Korea 18th International Jewelry Design Contest – Four Special Selection Awards and ten Honorable Mention Awards.

— TTF: Year of the Pig Jewellery Design Contest – Two Top Ten Awards and Finalist.

— China Fei Cui Excellence Award – Bronze Award and Nomination Award.

— The 2nd Shangtang Silver Town Creative Jewelry Design Award – Bronze Award.

— ShanXiaHu Creative Pearl Jewelry Design Award – Excellence Award. Awarded piece is sponsored by Ruan's Pearl for manufacturing.

— Zhong He Sheng Shi Jewelry Design Contest – 3rd Prize Award, Best Craft Award. Awarded pieces are sponsored by the organizer.

— Singapore Jewellery Design Award – Finalist.

— The 2nd Zhao Jin Cup Gold Jewelry Design Award – Seven Excellence Awards.

— The 9th China Jewelry Design and Craftsmanship Contest - Best Style Award.

2017

— Korea 17th International Jewelry Design Contest – Two President's Awards, two Designer's Excellence Awards, two Special Selection Awards and four Honorable Mention Awards.

— Singapore Jewellery Design Award – Winner, 1st Runner up and two Finalists.

— International Creative Jewellery Design Competition - Gold Award.

— TTF: Year of the Dog Jewellery Design Contest – Top Ten Award and Finalist.

— Ct+ Diamond Ring International Jewellery Design Competition – Finalist. Awarded pieces are sponsored by TTF Haute Joaillerie for manufacturing.

— International Design Competition on Trendy Fei Cui Jewellery – 3rd Prize Award of Open Group Drawing category.

— JMA International Jewellery Design Competition – Commended Award, and Nomination Award.

— CPAA's International Pearl Design Competition – Visionary Award.

— International Opal Jewellery Design Award
– Two High Commendation Awards.

— Culture and Creative Jewelry and Product
Design - Finalist

2016

— CPAA's International Pearl Design
Competition – President's Trophy,
Designer's Award and Visionary Award.
Awarded pieces are sponsored by Chow
Tai Fook Jewellery Group, Katex Jewellery
Ltd, Leo Foo Group for manufacturing and
presented at AGTA and JCK exhibition in
the U.S.A.

— Singapore Jewellery Design Award –
Winner, 2nd Runner up and eight Finalists.

— 1Ct Diamond Ring TTF International
Jewellery Design Competition – Silver
Prize. Awarded pieces are sponsored by
TTF Haute Joaillerie for manufacturing.

— Chuk Kam Jewellery Design Competition
– Three Winners and eight Finalists.
Awarded pieces are sponsored by Chow
Tai Fook Jewellery Group, Katex Jewellery
Ltd, Leo Foo Group for manufacturing.
Winners are nominated for Hong Kong
Trade Development Council's Champion
of the Champions Award.

— The 1st China International Pearl Jewelry
Design Competition – 2nd Prize Award,
3rd Prize Award, five Excellence Awards
and thirteen Finalists. Awarded pieces
are sponsored by Pure Pearl Group
Co., LTD and Hai Tian Sheng Pearl for
manufacturing.

— The 1st China Shunde Innovative Jewelry
Design Contest – Silver Eagle Prize and
three Finalists.

— The First Yu Yao Jiang Jewelry Design
Competition – 2nd Prize Award of
Wedding Dress Category, 3rd Prize
Award of Evening Dress Category, 3rd
Prize Award of Work Outfit Category,
four Emerging Designers Awards, three
Finalists and eight Nomination Awards.

— TTF: Year of the Rooster Jewellery
Design Contest – Finalist.

— GIT World's Jewelry Design Awards –
3rd Prize Award and Finalist.

— Korea 16th International Jewelry Design
Contest – Three Designer's Excellence
Awards, four Special Selection Awards
and four Honorable Mention Awards.

— JAS Jewellery Design Competition –
Three Nomination Awards.

— JMA International Jewellery Design
Competition – Five Finalists.

2015

— CPAA's International Pearl Design
Competition – Luster Award, Brilliance
Award, Orient Award and Wedding
Day Pearls Award. Awarded pieces
are sponsored by Liangher Jewellery
Company Ltd for manufacturing,
and presented at AGTA and JCK
exhibition in the U.S.A.

— International Opal Jewellery
Design Awards – Winner and ten
High Commendation Awards.

— Shanghai International Jewellery
Design Competition – Finalist of
the Students Group and three Finalists
of the Professional Group.

— Korea 15th international Jewelry Design
Contest – Two Designer's Excellence
Awards and four Special Selection Awards.

— DIJW Jewellery Design Award – Finalist of the
Best Arabic Jewellery Award, Finalist of CAD/
CAM Technology Award and two Finalists
of Innovative Jewellery Design Award.

— China Jewelry Design and Production
Competition – Best Innovative Jewellery
Award and two Excellence Awards.

— The 2nd Chinese Impression Peacock Jewelry
Design Contest – Two Best Hand Sketch
Awards and three Fan Favorite Awards.

— JMA International Jewelry Design
Competition – Finalist.

— The 4th China International Jewelry
Design Competition – Excellence Award
of the Professional Group.

2014

— Shanghai International Jewely Design
Competition – 3rd Prize and Best
Craftsmanship Award. Awarded piece is
manufactured by G&D Jewelry Design.

— The 4th China Shunde Lun Jiao Innovative
Jewelry Design Contest – Silver Prize.

— China Jinxiangyu Innovative Design
Competition – Best Innovation Award.

— Chuk Kam Jewellery Design Competition–
Finalist.

— CPAA's International Pearl Design
Competition – High Commendation Award.

— The 1st Chinese Impression Peacock
Jewelry Design Contest – Excellence Award.

— The 4th Shenzhen International Jewelry
Design Competition – Excellence Award
of Professional Group

2013

— International Opal Jewellery Design
Awards – Winner and nine
High Commendation Awards.

— DIJW Jewellery Design Award – Winner
of Innovative Jewellery Design Award.

— CPAA's International Pearl Design
Competition – Orient Award and two
High Commendation Awards.

— The 3rd Shenzhen International
Jewelry Design Competition –
Excellence Award of Professional Group;
two 2nd Prize Awards, 3rd Prize Award
and Excellence Award of Student Group.
Awarded pieces are sponsored by Fine
Pearl for manufacturing.

— The 9th International South Sea Pearl
Jewellery Design Competition –
Public Group: Silver Prize of earrings
category, Silver Prize of brooch category,
three Merit Awards; Student Group:
First, Second and Forth Awards.
Awarded pieces are sponsored by Victoria
Jewelry design for manufacturing.

— MIJF Jewellery Design Awards –
Winner of necklace category and
Finalist of brooch category; Winners are
awarded by Taiwan Ministry of Culture.

2012

— IU Awards- International Jewellery Design
Competition – Merit Award and three
Finalists. Winners are awarded by Taiwan
Ministry of Culture. Awarded pieces
are sponsored by Liangher Jewellery
Company Ltd for manufacturing

— MIJF Jewellery Design Awards – Winner
of bracelet category and brooch category.
Winners are awarded by Taiwan Ministry
of Culture.

— Fashion China - CCTV Colored Stone
Jewelry Design Contest –
Three Excellence Awards.

— CPAA's International Pearl Design
Competition – High Commendation Award.

— Taiwan Gemstone Coral Design
Competition – 2nd Prize Award.

2011

— International Opal Jewellery Design
Awards – Five High Commendation
Awards and two Finalists.

— Taiwan Gems Association Jewelry
Design Competition –
Romantic Wedding Merit Award.

水流星/盧佩吟
2016中國首屆國際珍珠首飾設計大賽
二等獎

千足珠寶有限公司贊助製造
設計手稿/頁78

潺潺流水 Murmuring Stream/蔡宜軒
2016美國國際珍珠首飾設計比賽
總冠軍

香港周大福珠寶集團贊助製造
設計手稿/頁72

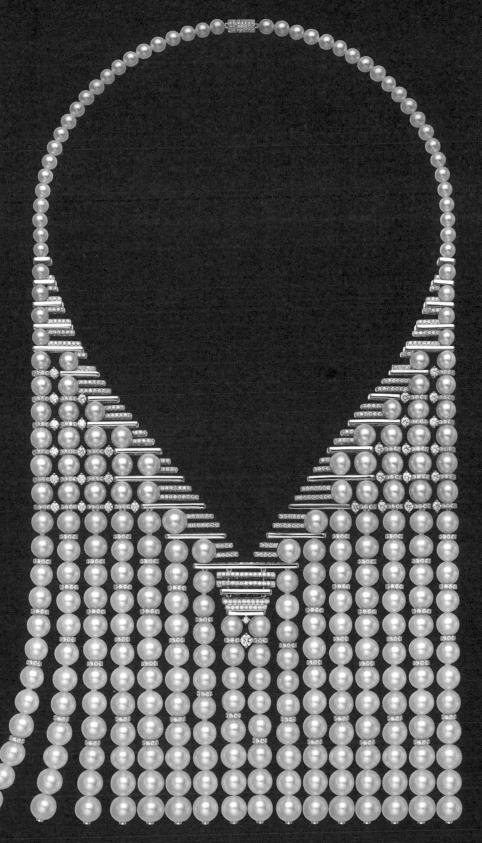

平安團圓 Safe and Sound/呂宜姍
2016美國國際珍珠首飾設計比賽
最佳視覺大獎

香港周大福珠寶集團贊助製造
設計手稿/頁76

夏日情懷/邱瓊瑩
2013香港第九屆國際南洋珠首飾設計大賽
公開組優選獎

維多利亞珠寶贊助製造
設計手稿/頁79

196

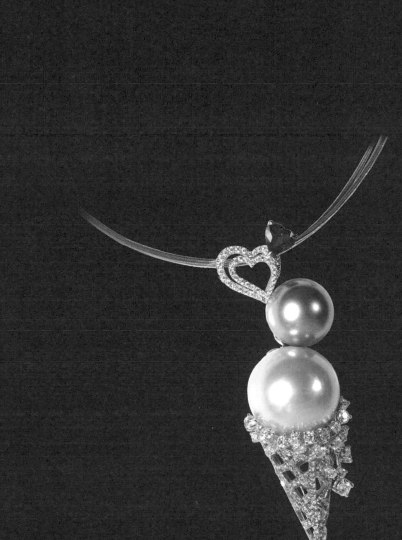

珍藏 Cherish/蔡宜軒
2013中國第三屆國際珠寶首飾設計大賽
二等獎

深圳市丰沛珠寶贊助製造
設計手稿/頁82

綻放未來/殷璐妍
2016香港足金首飾設計比賽
金獎

香港周大福珠寶集團贊助製造
設計手稿/頁142

福滿/呂宜姍
2018香港足金首飾設計比賽
銀獎

香港周大福珠寶集團贊助製造
設計手稿/頁147

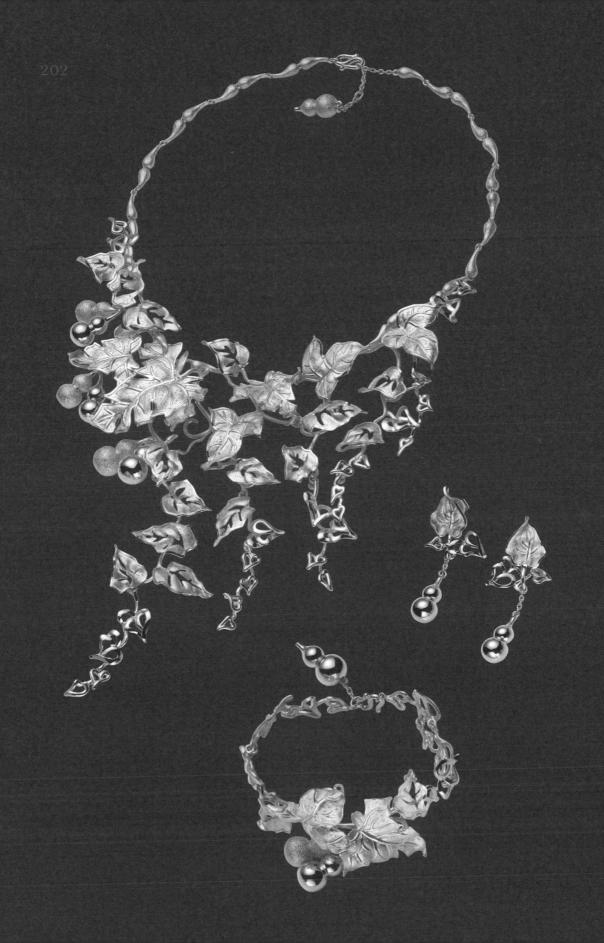

祝福花串/張愷芬
2018香港足金首飾設計比賽
金獎

香港周大福珠寶集團贊助製造
設計手稿/頁146

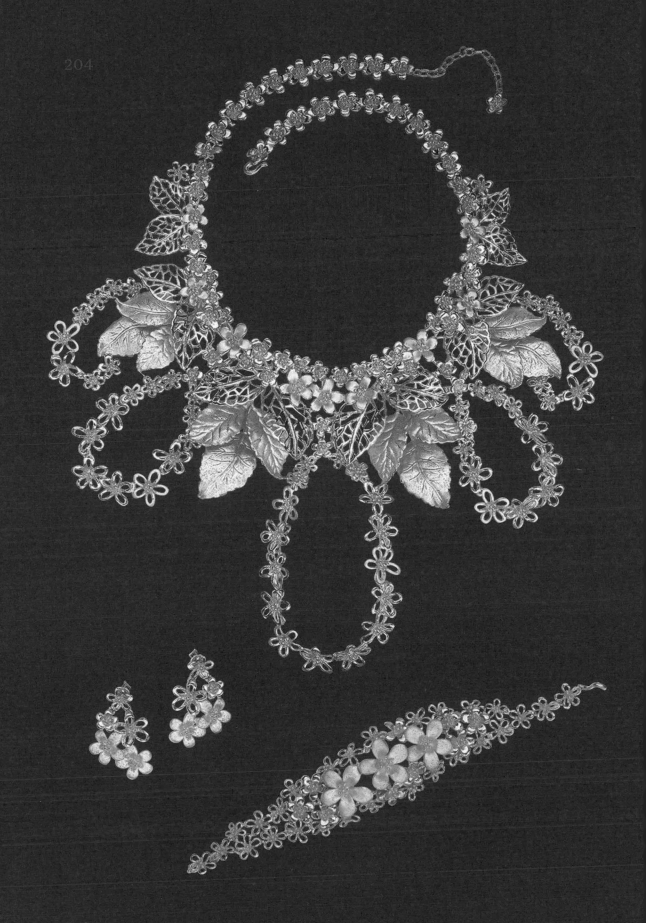

祿/丁琬芳
2016香港足金首飾設計比賽
金獎

香港周大福珠寶集團贊助製造
設計手稿/頁150

秘境/陳盈盈
2014上海國際首飾設計大賽
最佳工藝製作獎

結締珠寶製造
設計手稿/頁70

珠寶設計原創繪本

主編／臺灣珠寶藝術學院
總策畫／盧春雄
文字整理／蔡宜軒
企畫編輯／吳祝銀、李曉晴
封面設計／蔡叡玫 Rosy Tsai
美術編輯／蔡叡玫 Rosy Tsai

總編輯／賈俊國
副總編輯／蘇士尹
編輯／高懿萩
行銷企畫／張莉滎、蕭羽猜、黃欣

發行人／何飛鵬
法律顧問／元禾法律事務所王子文律師
出版／布克文化出版事業部
台北市中山區民生東路二段141號8樓
電話／(02)2500-7008 傳真／(02)2502-7676
Email／sbooker.service@cite.com.tw

發行／英屬蓋曼群島商家庭傳媒股份有限公司城邦分公司
台北市中山區民生東路二段141號2樓
書虫客服服務專線／(02)2500-7718;2500-7719
24小時傳真專線／(02)2500-1990;2500-1991
劃撥帳號／19863813;戶名／書虫股份有限公司
讀者服務信箱／service@readingclub.com.tw

香港發行所／城邦(香港)出版集團有限公司
香港灣仔駱克道193 號東超商業中心1樓
電話／+852-2508-6231 傳真／+852-2578-9337
Email／hkcite@biznetvigator.com

馬新發行所／城邦(馬新)出版集團 Cité (M) Sdn. Bhd.
41, Jalan Radin Anum, Bandar Baru Sri Petaling,
57000 Kuala Lumpur, Malaysia
電話／+603-9057-8822 傳真／+603-9057-6622
Email／cite@cite.com.my

印刷／韋懋實業有限公司
初版／2022年5月
定價／2,000元
ISBN／978-986-0796-53-7 (精裝)
EISBN／978-986-0796-52-0 (EPUB)

城邦讀書花園
www.cite.com.tw

布克文化
WWW.SBOOKER.COM.TW

臺灣珠寶藝術學院
Jewellery Institute of Taiwan